DUBLIN
CALIFORNIA

DUBLIN
CALIFORNIA
· A BRIEF HISTORY ·

STEVEN MINNIEAR

WITHDRAWN

THE
History
PRESS

Published by The History Press
Charleston, SC
www.historypress.com

Copyright © 2018 by Steven Minniear
All rights reserved

First published 2018

Manufactured in the United States

ISBN 9781625859655

Library of Congress Control Number: 2018932118

Notice: The information in this book is true and complete to the best of our knowledge. It is offered without guarantee on the part of the author or The History Press. The author and The History Press disclaim all liability in connection with the use of this book.

CONTENTS

ACKNOWLEDGEMENTS

I would like to thank many people and institutions for making this history possible. If it takes a village to raise a child, then it takes a community to write a book. I've been blessed to be part of a very generous community of people interested in the history of where they live or where they used to live.

First, I want to acknowledge Virginia Bennett. Originally a librarian working at the Alameda County Library, she worked at several of the Dublin libraries. Her commitment to serving all the new families who moved to Dublin after 1960 grew to include an interest in the early history of the area. She went on to collect and publish the stories of those who moved to the area from 1846 through the rest of the nineteenth century. They were the ones who left the few remaining wooden buildings clustered near the old Dublin crossroads.

Next came the many early Dublin Historical Preservation Association (DHPA) members—including Marie Cronin, Donna Kolb and others—who took on the daunting responsibilities of saving, maintaining and restoring two important Dublin landmarks: old St. Raymond's church and the original (and often moved) Murray School House. Marie Cronin's legendary efforts to protect other buildings from overly zealous and misguided volunteer firefighters may have failed, but they sparked a community dedication that resulted in collection of many historic artifacts. Besides buildings, the many DHPA members collected early documents and photographs that are often our only links to the late 1800s and the early 1900s. Later DHPA members

were also the early advocates for Dublin's incorporation. That in and of itself should be recognized as a significant historic effort and event. Since they were successful, they also wound up convincing the Dublin city government to take a critical role in historic conservation, resulting in truly important accomplishments: the Dublin Heritage Park & Museums and the Dublin Camp Parks Military History Center. Without the dedication and support of DHPA members and early civic pioneers such as Janet and Steve Lockhart, Tom McCormick and others too many to mention, this book could not have been researched and written. I would also like to thank past DHPA board member and local historian Don Meeker for introducing us to the White Angel, Lois Jordan.

Local historian Ken MacLennan proved to me (and our area) that it is possible to write a good history of a local suburban city when he finished *Pleasanton, California: A Brief History*. He showed me a way to approach nearby history that I would not have found myself. He shared facts and fiction and advice that sparked and sustained this effort. Thanks also to all the wonderful people at Pleasanton's Museum on Main, including Director Jim DeMeersman and volunteer Judy Rathbone Burt.

Similarly, I owe a debt of gratitude to other local historians and organizations. Beverly Lane and the Museum of the San Ramon Valley reinforced my understanding of the linked nature of our local history. Dublin's history is also the history of Contra Costa County, Danville and San Ramon. Thanks also to John Mercurio and the Contra Costa Historical Society. I would not know so much about our shared roads, especially the history of Highway 21, without him. Jeff Kaskey and the staff at the Livermore Heritage Guild's Carnegie Library were critically important in providing the other close connection to Dublin's history that came from the links to Livermore's story. And much of this history was helped by the knowledge and experience of Dublin historian (and DHPA stalwart) Georgean Vonheeder-Leopold.

Another set of thanks goes to the City of Dublin staff for their ongoing work documenting the history of Dublin. I especially thank Elizabeth Isles, the director of the Heritage Park & Museums, and her assistant, Emily Contrado. Without Elizabeth's work, there would be no modern history of Dublin. It's important to me to mention the city council and administration's importance to collecting, interpreting and disseminating Dublin's history. The Dublin City Council, in all its various compositions, has been a stalwart supporter of local history, not just Dublin's history, since 1982. Thank you for having the vision to stay the course of historic

preservation and promotion. You were among the first local governments to create the position of city historian. I would also like to thank current and past administrators such as city managers Joni Pattillo and Chris Foss and Park and Community Services directors Paul McCreary and Jim Rodems. The city's Heritage and Cultural Arts Commission, in its many compositions, inspired me to keep local history in front of the public.

None of this history would have started without the dedication of many unheralded volunteers. Over the years, and especially from the 1960s through the 1980s, local volunteers took upon themselves the preservation of Dublin's remaining physical history. These volunteers started with DHPA and went on to work with the Heritage Park & Museums. They keep the ever-growing mass of artifacts, documents and photographs organized and available for us. Thank you for those long hours, often alone, amid dusty, smelly stuff.

There are two special people who were critical to my dawning awareness that Dublin deserved a more extensive written history. One is no longer with us, and the other is still with us but far away. Ada "Tommie" Simpson came to California as part of her World War II navy service. She served, fell in love, got married here, left the navy, lived in the area and recently died near here. She helped start a small history center that opened, worked, closed and is now reopened. While spending weekends in an old, dirty, dusty Camp Parks guard shack, I helped inventory the large number of World War II, Korean War, Cold War, Gulf Wars and other periods' artifacts, documents and photographs. That experience, touching and examining other people's lives through the stuff they held, made me appreciate them, their service and Dublin's story in a way I never had before. I committed myself to bring Dublin's history to our community and the larger Tri-Valley area. Terry Berry, a local museum consultant and longtime museum lover, helped in that inventory effort. Over the years, she helped me understand the museum and archive business, how local museums worked and how small museum staffs and volunteers made things happen. Without the inspiration and wisdom they brought me, I never would have attempted this history. Rest in peace, Tommie, and enjoy Oklahoma, Terry.

If we've forgotten someone important (and you will know who you are, and you will probably tell me at some point in the future), I apologize.

Finally, I would like to send a special thank-you to my spouse and family. Thank you. They were so kind and helpful, especially Pamela and her review of early drafts. They didn't throw me out of the house or car when

I said for the thousandth time, "And you want to know another thing about Dublin's history?"

Naturally, any mistake in this book's content or argument is my own and is not due to any of the people who helped. Knowing the nature of historical works, especially local historical works, I'm pretty sure there are mistakes. History gets better with time and research.

INTRODUCTION

There was a time when, if you knew of Dublin at all, the only thing you knew about it was that it was the place you went to die or get injured in a grisly accident. And over the years, the only thing that changed was whether it was a grisly carriage, stagecoach, wagon, automobile, motorcycle or truck accident. Later, you might learn that Dublin was where you went to buy an inexpensive house or live among the highest per capita concentration of fast-food restaurants in America. Even later, for a very brief time, Dublin was the place you went to have a reality television show crew shoot a cannonball through your house and car.

Dublin has always been much more than that. From the distant past, it was the place to live your life, like almost any other place on earth. But like any other place, Dublin has a unique history that is worth telling. That history, contrary to what most of its past and present residents think they know, includes people and events that affected the area, county, state, country and, arguably, the world.

Dublin, California, currently (as of 2018) includes more than fifty thousand residents. It's easily identifiable on a San Francisco Bay Area map as the city centered on the intersection of Interstates 580 and 680. It's about twenty-eight miles southeast of San Francisco. The location, near two modern interstate highways and San Francisco, highlights a critical historical situation: it was a crossroad between San Francisco and the rest of the country and a crossroad between Northern and Southern California. The real estate mantra describing the value of a property says, "Location,

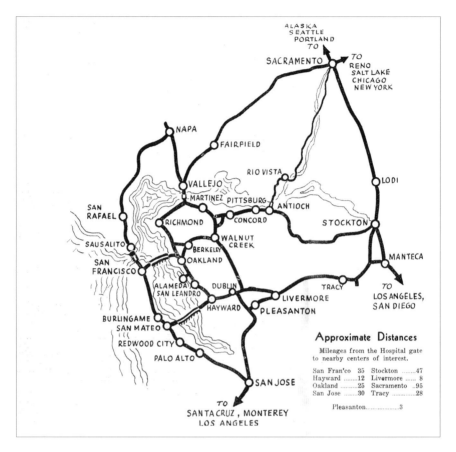

This map, adapted from a 1940s-era image, shows Dublin in relation to the San Francisco Bay area and connected by two-lane highways. *Author's adaptation of World War II U.S. Navy map.*

location, location." There should be a historical phrase describing the importance of a place in history in similar way: "Location, location, location and roads."

The general location of "Dublin" didn't change much over time. Modern Dublin started with the city's 1982 incorporation. It was and still is north of Pleasanton, east of Castro Valley, south of San Ramon and west of Livermore. It is wholly located within Alameda County.

In 1982, it stretched from the base of the western foothills to Dougherty Road and from the Contra Costa border in the north to Interstate 580 in the south. By 2017, Dublin had reached from the crest of the foothills in the west all the way to Croak Road in the east. It occupies nearly fifteen square

miles. The north and south boundaries remained the same. Up until the early 1800s, several Native American villages belonging to separate tribes were probably located in an area roughly including current San Ramon, Dublin and Pleasanton boundaries. Between the late 1800s and early 1900s, some residents thought of Dublin as centered on the crossroads of San Ramon/Pleasanton Road and the Stockton/Hayward Road (Dublin Boulevard) but reaching a few miles to the south and east. In general, though, for this book, Dublin corresponds to the general area bounded by the Alameda/Contra Costa County boundary on the north, Tassajara Road to the east, Stoneridge Drive (in Pleasanton) on the south and the crest of the hills to the west on both sides of Interstate 580.

The wide-scale introduction of road numbers started in California in the 1930s. Before that, roads were marked, if they were marked at all, by where they went. If you were in Dublin and wanted to go to Pleasanton, you looked for Pleasanton Road. Later, when you were in Pleasanton and wanted to go back to Dublin, you looked for a sign marked Dublin Road. We still have remnants of that convention. Depending on where you start, you can still get to San Ramon by using San Ramon Road. Or you can get where you want to go by using Santa Rita Road or Pleasanton Road or Dublin Boulevard. Over time, some roads had multiple names, even along the same route. Thus, the Hayward/Dublin, Hayward/Stockton and Dublin/Livermore roads were all the same road. That route later became the Lincoln Highway, Highway 50 and is now what we know as Interstate 580. Throughout this book, I often use the road name as it was used at that time to remind the readers what destinations the travelers had in mind when they were on the road. Sometimes I will mention the current road name to give readers a better sense of the location being described.

This history depends heavily on the written record, such as it is. This means that the Native American history is only poorly known, which is very unfortunate since they lived here the longest. Like much California history, what we know about the past starts to be written down with the beginning of Spanish colonization. For Dublin, this means written history starts in the late 1700s. The documentary record is sparse through the Mexican period and up to the Gold Rush and statehood. Even during the 1800s, there wasn't much written about Dublin since it was relatively distant from San Francisco, Oakland and San Jose. Local newspapers in Pleasanton, Livermore and Martinez gave Dublin passing notice, and researchers are lucky when they find the occasional column or comment about the crossroads and farms. This problem continued through the 1900s and until the 1960s, when the

Village Pioneer expressly said it would cover the newly developing community of San Ramon Village. With more news sources and activities, Dublin's evolving history was better documented. Since there had to be a cutoff date, 2000 was picked. To some extent, it seems that events after that are less like history and more like recent events.

This history will often highlight the importance of location in influencing Dublin's development. Dublin is a part of Amador Valley and closely connected to the San Ramon and Livermore Valleys. At the same time, it is part of Alameda County and adjacent to Contra Costa County. It is also part of the Greater San Francisco Bay Area. Dublin and its crossroads provide an important link between Northern and Southern California. Dublin's location is a critical part of its past and its present.

Please enjoy your visit through Dublin's varied history.

Chapter 1

WE ALWAYS LIVED HERE

The earliest residents of what would become Dublin were Native Americans. We have very few written sources telling us much about their lives. And sources are often contradictory or heavily influenced by the biases of the authors, their cultures and their times. What follows is a very imperfect summary of what we know now.

Archaeological evidence suggests that Native Americans lived here for tens of thousands of years. They are undoubtedly the first residents and the residents who lived here longest. Their beliefs say they were here at the dawn of time.

The number of Native Americans probably varied over time in response to weather and plant and animal populations. It's possible there were between 200 to 400 Native Americans living in the Amador Valley at the time the Spanish started moving into the San Francisco Bay Area.[1] By 1846, one estimate suggests there were 145,000 Native American residents in California.[2] There had been 340,000 in 1769 when Spanish colonialization began.[3]

Native American traditions, Spanish and Mexican documents, late nineteenth- and early twentieth-century academic research and modern reinterpretations of many sources suggest the following information. The Seunens, Yrgins, Pelnens and Ssouyen tribes lived in parts of what is now Dublin. They were several small tribes linked by language and kinship that lived in several different, adjacent areas. In the period before Spanish expansion into the San Francisco Bay Area, Native Americans lived in small

tribal regions often eight to twelve miles in area. Each had a population varying from two hundred to four hundred people.[4] While usually having one long-term village location, they often had small locations they lived in during different seasons to take advantage of local crops and wildlife. Villages could be found along local streams about every four miles.[5] The plentiful wildlife, water and easy passage to the San Francisco Bay Area, the Central Valley and the Santa Clara Valley resulted in a rich mixture of interacting and interconnected but separate communities.

Despite being relatively close together in modern terms, each tribe was separate and distinct with its own territory. The tribes were probably nearly self-sufficient within the area they occupied. Unique languages developed for the communities, but there were probably many multilingual individuals. Trade and marriage likely transcended local boundaries and promoted cross-tribal communication. Dublin-area Native American tribes were located on the border of two larger general language areas: Chochenyo Ohlone and Bay Miwok.[6]

In general, the Native American names for their tribes were lost during the cultural disruption caused by the Spanish arrival and expansion.

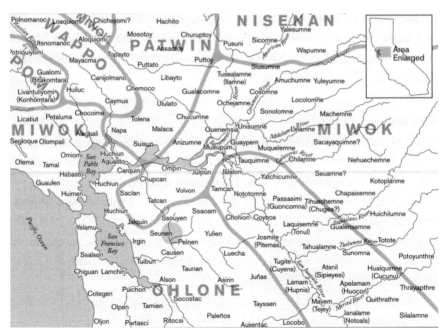

There were numerous permanent and temporary Native American communities in and around what is now Dublin (indicated by the gray circle). *Malki Museum, from Randall Milliken, Native Americans at Mission San Jose.*

Subsequently, others identified the tribes not by their own names but by the languages they spoke. The Seunens lived in the Dublin–San Ramon area. The main village might have been near Alamilla Springs, the natural springs at the eastern edge of Dublin Canyon. Or the village might have been farther north in San Ramon, possibly near the entrances to Crow, Norris or Bollinger Canyons. The Yrgins, which may be the same group as the Jalquins, lived in the hills between Dublin and San Leandro. They were closely connected to the Seunens. The Pelnens lived in the western part of the Livermore Valley in the area around Dublin and Pleasanton, including the area south of Dublin leading to the Sunol Valley. To the north, the Tatcan village may have been near either Danville or Walnut Creek. The Ssouyen lived along Tassajara Creek, which was at the north end of the very large lake that existed then between Dublin and Pleasanton.[7] The Seunens, Yrgins, Pelnens and Ssouyen tribes spoke Ohlone-related languages. The Tatcans spoke a Miwok-related language.[8]

Native Americans generally lived with the situation as they found it: plentiful water, diverse animal and plant life and generally moderate weather. At that time, one of the determining ecological factors was the huge lake that extended throughout the western Livermore and southern Amador valleys. Roughly speaking, the lake extended from Dublin to Pleasanton. While it provided a diverse source of plant life and wildfowl and aquatic life, it also limited traveling through it, as well as providing abundant insect breeding grounds.

The Dublin area was a natural place to live since it offered several advantages. There were small streams such as Tassajara Creek and the Arroyo Mocho, as well as artesian wells that provided sufficient safe water. The lake was also a large freshwater marsh. It provided a home for wildlife, grasses and reeds that were essential to the Native Americans' life.

The location also provided an easily walkable route between the Central Valley and the San Francisco Bay along the creeks in Dublin Canyon. The gently sloping San Ramon and Amador Valleys allowed an easy route from Carquinez Strait and Suisun Bay through the San Ramon and Amador Valleys toward the Sunol and Santa Clara Valleys. As one author said, "West-central people were bound together by bonds of commerce and economic reciprocity, as well as intermarriage among neighboring groups." In addition, "Individual well-being derived from participation in group resource extraction, group resource sharing, and group celebration."[9] Trade included unshaped seashells, obsidian, basket materials, finished baskets, arrow shafts, finished arrows, bows, bird feathers, minerals for paint, tobacco

and other commodities.[10] In general, items moved from tribe to tribe along the two routes that went through the Dublin area.

The migration of Spanish missionaries, soldiers and settlers into the San Francisco Bay Area in the mid- to late 1700s had disastrous consequences for the Native Americans. Starting with the introduction of cattle, seeds brought from Mexico and Spain introduced invasive plants that eventually supplanted many indigenous plants. Many of the plants lost were critical to the Native American diet and life. At the same time, the increasing cattle herds denuded the hillsides, further reduced native plants and destroyed habitats for local animals. The decreasing plant and animal population exhausted Native American food sources.

At this point, cultural interactions with the Spanish missionaries resulted in more damaging effects. As Mission San Jose was organized and built, the mission priests and staff started inviting, encouraging and sometimes coercing local tribes to visit and stay. Initial Native American interest in the newcomers brought many of nearby tribes to visit and trade. The Spanish had many items such as iron knives, tools, jewelry and beads, cattle, oxen, horses and leather products that were unknown and potentially useful to Native Americans. The impact of iron swords, leather and steel armor and horse-borne warriors with lances was also unprecedented. There may have been a profound misunderstanding by Native Americans of the early exchange of items; the exchanges were not merely a gift exchange. And at the earliest stages, the Spanish were relatively few, and their communities were not much larger than the tribes near them. The Native American tribes probably underestimated the impact these new neighbors would have on the area.

The Spanish missionaries used their well-developed colonial and missionary practices to insinuate themselves into the local political, social and economic environment. The missions were organized and structured to convert individuals and tribes from their local religious practices to Roman Catholicism as it was then practiced throughout the Spanish empire. They had honed the practices for several hundred years in Spain and throughout the Americas. From the missionaries' viewpoint, their actions were necessary to bring their religion to those who otherwise would be destined to eternal damnation. The missionaries' practices closely complemented Spanish colonial economic and political interests.

According to mission practices, once Native Americans were baptized, they gave up their right to leave. This came as a shocking, confusing and alien concept to them. Native Americans who chose not to accept their

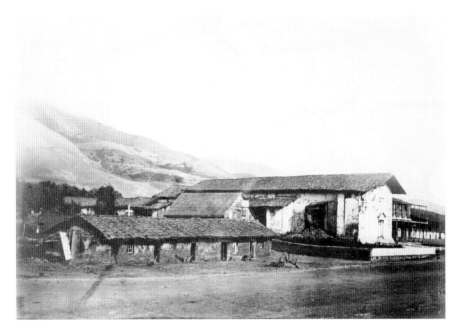

Mission San Jose is fourteen miles south of the Dublin crossroads. It was critical to Dublin's development through the Spanish and Mexican periods. *Dublin Heritage Park & Museums.*

involuntary servitude tried to leave, if they could. Many could not. Mission staff controlled their actions, directing when and where they would eat, sleep and work. Strict segregation of the sexes saw women and children locked up in buildings at night. The commingling of Native Americans with other tribes broke down communal ties and introduced suspicion and confusion. A strict religious education was a daily part of this life, adding to the sense of rapid change. New (and to them unusual) skills such as herding, planting, weeding, crop harvesting, carpentry and leather working further disrupted Native Americans' ways of life. In addition, typically common Spanish and European ideas of punishment—including beating, flogging and verbal harassment—reinforced control over Native Americans at the missions. In addition to all those crises, overcrowding and poor sanitation at the missions led to frequent sickness, which often resulted in death. These circumstances suggest to many historians and modern Native American representatives that the situation should be described as genocide.

Mission San Jose grew, and local Native American tribes were amalgamated into it. As the mission Native American population fell due to disease and death, missionaries and their staff expanded their search for new

converts to areas north and east of Mission San Jose. From around 1801 to 1805, the Seunen tribe in and around what is now Dublin and San Ramon came under mission control.[11] The land in the Amador, San Ramon and Livermore Valleys became prime grazing land for the vast mission herds. Other local tribes, such as the Pelnens and the Ssouyens, soon became part of the mission population. In 1805, nearly all the 812 Native Americans at Mission San Jose spoke Chochenyo Ohlone.[12] However, many died at the mission in the measles outbreak in 1806.[13]

From 1809 through 1835, Mission San Jose increasingly relied on willing and unwilling converts for work at the mission. They came from areas in the Sacramento and San Joaquin Valleys and from the north bay area. The area around Dublin continued to be grazing area for mission herds. Mission Native Americans managed vast numbers of cattle, horses and sheep. Several outstations existed, including Rancho del Valle in the western Livermore Valley.[14] This may have been the beginning of Spanish occupation at Alamillo Springs. As late as 1835, there were still 72 Native Americans at Mission San Jose (out of 1,964) who spoke Chochenyo Ohlone languages, and they probably had lived in and around Dublin.[15]

During this period, Mexico became independent from Spain. California became a Mexican province following independence in 1821.

The year 1836 brought profound changes to the mission and the Native Americans living there. In response to a change in Mexican government policy, Mission San Jose closed as a religious mission in late November 1836. It was one of the last missions to be transferred from religious to government and private control, known as secularization. The Mexican government started the process in 1834 in partial response to many prominent families throughout California desiring the very valuable land and livestock. Some of the outlying mission lands were sold earlier. For example, Mexican governor José Figueroa officially granted Jose Maria Amador a land grant in the Amador Valley in 1835.

While the properties were by law to be distributed to the Native American residents, the first civilian administrator assessed that the Native Americans did not need any of it. Thereafter, local landowners started to petition for land close to the mission. From 1837 through 1839, the mission population declined from 1,550 to 589. Many recent Native American converts returned to their homes from the Sacramento, Consumnes and Mokelumne river areas. Some 150 Native Americans died during a smallpox epidemic in 1838. Some, probably including Chochenyo Ohlone and Bay Miwok inhabitants originally from the Dublin area, found work as domestic help,

Mission San Jose used resources from a vast area around it (the Dublin area is indicated by a gray circle). *Malki Museum, from Randall Milliken, Native Americans at Mission San Jose.*

caretakers, cowboys (vaqueros) and laborers in the nearby land grants. From 1830 through 1852, former Mission San Jose Native American names appear in baptismal records, indicating that many stayed in the area.[16]

The short war between Mexico and the United States ended in California when U.S. troops and local Mexican forces signed the Treaty of Cahuenga in January 1847.[17] The war formally ended with the signing of the Treaty of Guadalupe Hidalgo in February 1848. The Gold Rush dramatically increased the number of new people coming to the state and disastrously affected Native Americans living in the Central Valley and Sierra Nevada and throughout the state. California became a state in 1850. Native Americans continued to live and work in the area. The 1852 Contra Costa census identifies several Native Americans in the Dublin area.

By 1875, many residents thought the Native American presence was so minimal that merely finding an arrowhead became sufficient for notice in the newspaper. On June 28, 1875, a short newspaper article in the *Oakland Tribune* described Mr. Mann finding an arrowhead on the road between Hayward and Dublin.[18] Nonetheless, at that very time, a small community

of Native Americans, including descendants of Dublin-area tribes, lived just west of Pleasanton. The Alisal community continued to maintain many Native American traditions.

Today, the Muwekma Ohlone tribe of the San Francisco Bay Area continues to advocate for Native Americans descended from Mission San Jose inhabitants. Their effort to obtain federal status as a recognized tribe is ongoing.[19]

Chapter 2

WE SETTLED HERE

Dublin had many settlers. After the Native Americans who lived there for thousands of years, there were four main groups that settled in Dublin. The Spanish explorers who started to arrive in the San Francisco Bay Area in the 1700s traveled through the Amador Valley on expeditions to explore the area, usually as they were passing through evaluating the land for settlement, agriculture and pasturage. By the late 1700s, missionaries from Mission San Jose (established in 1797) and their guards had ventured in the valley looking for converts. Later, Mission San Jose workers, usually Native Americans, herded cattle, sheep and horses in the area around Dublin, Pleasanton and Livermore. It wasn't until the Mexican period started around 1821 that permanent non–Native American settlements started appearing in the valleys.

Next came a wave of settlers starting in 1846 that mainly came from the United States. That wave swelled immensely when the discovery of gold in California became widely known in 1848. After the establishment of the state of California in 1850 and the waning of the Gold Rush in 1853, settlement into the Dublin area slowed but continued. Throughout the remainder of the 1800s and early 1900s, other groups of settlers—including immigrants from Europe, especially from Ireland and what became Germany and Denmark—came to the Dublin area.

The largest (temporary) settler group in Dublin's history came because of World War II. Between 1942 and 1946, an estimated 350,000 men and a few hundred women lived, worked and trained at the massive U.S. Navy

complex a mile and a half east of the Dublin crossroads. They were followed in the 1950s by more than 40,000 men and women who trained, worked and lived at Parks Air Force Base. Since then, thousands temporarily settled at Camp Parks and Parks Reserve Force Training Area. (That history is described in chapter 4.)

The most recent group of settlers, and arguably the most important for Dublin's current history, started in 1960. Two developers, Kenneth Volk and Robert McLain, and their company broke ground for hundreds of entry-level and "executive" homes about three quarters of a mile north of the Dublin crossroads. Dublin's remarkable development since then expanded a small farm community situated on a major highway into one of the fastest-growing cities in California.

Along with the various settlers came interesting individuals and groups that temporarily lived in what would become Dublin. Sometimes they stayed for only short periods, but while they were here, they added to the local community in surprising ways.

THE FIRST PIONEERS

Jose Maria Amador (1794–1883) is the first prominent early resident we know much about. Born at the San Francisco Presidio (the Spanish military fortification in San Francisco) and the son of a soldier, he became a soldier himself from 1810 to 1827. During that period, he participated in retaliatory expeditions beyond the San Francisco Bay Area to return Native Americans to missions they had left.[20] An alternate view of the expeditions was that they were armed raids to recapture people who escaped from involuntary or voluntary servitude as workers at the missions. Periodically, the soldiers and their Native American auxiliaries would attack villages that harbored those they sought. And in the process of that, they would kill some or all the villagers and destroy the village.

From 1827 to 1835, Amador worked in several positions, including acting as the major domo (administrator or civilian foreman) of Mission San Jose.[21] In this position, he was the official responsible for administering the operations and land of the mission after it lost its religious standing. The missions and their assets were sold off or put under government control starting in 1831. The livestock, land, farm implements and buildings were usually sold. Native Americans were forced to leave and fend for themselves.

Mission San Jose was secularized in 1836. All the San Ramon, Amador and Livermore Valleys were the grazing lands for the mission. The mission drew on resources, and Native Americans, from this area and from the land in what would become eastern Contra Costa and western parts of San Joaquin and Sacramento Counties.[22]

Depending on the sources, Amador moved or spent time in and around Dublin around 1826. He eventually had his adobe home and other buildings constructed near what is now the Dublin Boulevard and San Ramon Road intersection. This became the headquarters for his roughly 17,600-acre estate, the Rancho San Ramon grant. Mexican governor Figueroa officially granted him the land in 1835. Through the 1830s, Amador had a large agricultural and manufacturing complex, which was unusual in California at the time. His workers made soap, leather goods (shoes, saddles and harnesses), farm tools and furniture. The rancho included as many as 400 horses, 14,000 sheep, pigs, thousands of cattle, a vineyard of 1,500 vines, an orchard of 50 trees and 150 employees.[23] Given the conditions of the times, it might be said that many of the Native American employees were there because they could find no other way to make a living and had nowhere else to live.

As late as 1837, Native Americans struggled with worsening circumstances and Mexican settler attacks. Many were driven off old mission lands and struggled to survive, having nowhere to practice the agricultural and pastoral skills they had learned. Mexican landlords increasingly pushed their grazing herds of cattle and horses to the east of the San Francisco Bay Area and into remaining Native American lands. Native Americans who still lived on their own lands in the Central Valley and Sierra Nevada Mountains increasingly had difficulties finding food. One alternative became raiding the Mexican herds in the Livermore Valley. In response, Jose Maria Amador and his men conducted or participated in retaliatory raids. One such punitive raid in 1837 resulted in a village being destroyed and at least two hundred Native American men, women and children being killed.[24]

Meanwhile, on the other side of the continent, interest grew in the United States about Oregon and California as places to settle. By the 1840s, more and more Americans began crossing the continent. Early interest in Oregon and California as fur trapping destinations gave way to interest in Washington, Oregon and California as places to raise cattle and farmland. Some early travelers described what they found in the Dublin and Amador Valley. John Bidwell came to California in 1841 as part of a small emigrant party:

After the others had left I started off traveling south, and came to what is now called Livermore Valley, then known as Livermore's Ranch, belonging to Robert Livermore, a native of England....Livermore's was the frontier ranch, and more exposed than any other to the ravages of the horse-thief Indians of the Sierra Nevada....That valley was full of wild cattle— thousands of them—and they were more dangerous to one on foot, as I was, than grizzly bears. By dodging into the gulches and behind trees I made my way to a Mexican ranch at the extreme west end of the valley, where I staid [sic] all night. This was one of the noted ranches, and belonged to a Californian called Don José Maria Amador.[25]

The year 1846 became one of great change in California. There was an open rift between the Mexican governor and his chief military commander that confused and confounded the situation in the state. In addition, the United States and Mexico went to war. Taking advantage of the situation, some disaffected Californians staged a minor rebellion near Sonoma and declared a republic. Meanwhile, American forces landed in Monterey and announced that California was now conquered territory. We don't know how Jose Maria Amador viewed the situation or which of the various sides he took during the period. A noted early California historian, Hubert Bancroft, merely mentioned in a footnote that Amador "was friendly to the Americans in the troubles of 1846."[26] Amador appears in other histories of 1846 only as one of the landowners who had his horses stolen by U.S. Army officer John C. Frémont as he passed through. To some extent, he probably took a wait-and-see attitude, as did many residents in California at the time.

Jose Maria Amador faced the same difficulties as most Spanish and Mexican landowners following California becoming part of the United States. Under the 1848 Treaty of Guadalupe Hidalgo, landownership was to follow Mexican law and was expected to be maintained. Instead, under federal legislation all land claims had to be confirmed before a land commission. This set off intense litigation that most Mexican landowners had difficulty managing. Among the many newcomers to California were lawyers who found handling the landownership cases easier, and more profitable, than mining. This resulted in lengthy and intense litigation. They often took their pay in property rather than cash and became large landowners themselves. Amador was one of the lucky few who had his landholdings confirmed in 1854. However, appeals, surveys and objections continued through 1860. It was only confirmed by President Lincoln's

signature in March 1865.[27] The legal costs were large, and eventually he had to sell much of his land to pay fees.

Between 1850 and 1852, Amador sold some of his lands to Jeremiah Fallon, Michael Murray, James Witt Dougherty, Leo Norris and others. His name does not appear in the U.S. census taken in August 1860 for Murray Township, as the area was then known. Sometime after all the legal land titles were resolved, probably by 1864, the now landless and poor Amador and his family moved to Whiskey Hill near what is now Freedom in Santa Cruz County. By the early 1880s, he had moved to Gilroy. Amador died in June 1883.

The Second Wave of Settlers

The second wave includes several different groups. It started with a few pre–Gold Rush settlers, then those who came to California for gold but found other reasons for staying in and around Dublin and then the many other mainly northern European settlers who came in the late 1800s. But it's important to note that people from all over the world—including Japan, China, southern Europe and South America—came to, or through, Dublin on their way to settle in the Amador, San Ramon and Livermore Valleys. The history of the second wave includes some early Irish immigrants who left the United States for Mexico. The history then revolves around one pivotal American Gold Rush emigrant and the many subsequent settlers from the eastern United States, Europe and the world. These are just a few of the many stories that could be told. Unfortunately, only a few prominent settlers are mentioned in written sources.

Founding Myths and Realities

The prevailing founding story of Dublin says that pretty much everything started with Michael Murray, Jeremiah Fallon and Eleanor (who was also known as Ellen) Murray Fallon. This ignores the Native Americans and pushes Jose Maria Amador, his family and everything they built to the background. And it has all the elements of a great story: leaving home, hardship, deprivation, near calamity, perseverance, tenacity, a love story, twists and turns and a happy

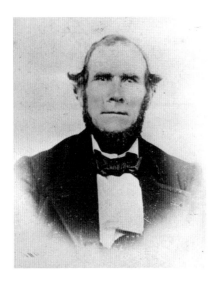

Michael Murray was the namesake for Murray Township, Murray School District and an elementary school. *Dublin Heritage Park & Museums.*

ending, sort of. And when elaborated upon, it has truths, untruths and half-truths all mixed together with little bits of factual history and little bits of misunderstandings. In these regards, the Murray and Fallon story is like many standard American immigration stories.

The story goes like this: Eleanor Murray and her brother, Michael, set out from Ireland with their friend Jeremiah Fallon. Eleanor and Jeremiah fall in love on the journey to America. Jeremiah goes to Louisiana to find his livelihood and achieves it. He comes back to New York City to marry Eleanor, and they start their life together in New Orleans. Michael is unhappy with his life in New York and moves west to start over. In 1846, he convinces Eleanor and Jeremiah to come with him and trek across the Great Plains to start an even better life in California. They cross the country in one of the first wagon trains, have adventures and avert disaster when they don't wait for the Donner Party after a rest on the trail. They reach California to start their life and get caught up in the Gold Rush. Michael and Jeremiah mine enough gold to buy a large amount of land from Jose Maria Amador, and they settle at the crossroads that will become Dublin. Michael becomes a prominent rancher, and a large part of Alameda County is named after him. Jeremiah and Eleanor become one of the prominent families in Murray Township. Michael and Jeremiah donate land for the first school and first Catholic church in the township.[28] And thus, the history of Dublin is started. At least that's the version that one of the Fallons' great-granddaughters wrote down.

It seems that the historical record does match with some of the story's elements. There are some details in the story that aren't quite right. The standard story also doesn't quite describe some of the more interesting details. And it does not even consider some of the usually unasked questions.

American history usually mentions that most Irish immigrated to the Unites States because of devastating potato crop failures. But the Murrays and Fallon did not leave Ireland because of that. Michael and Eleanor

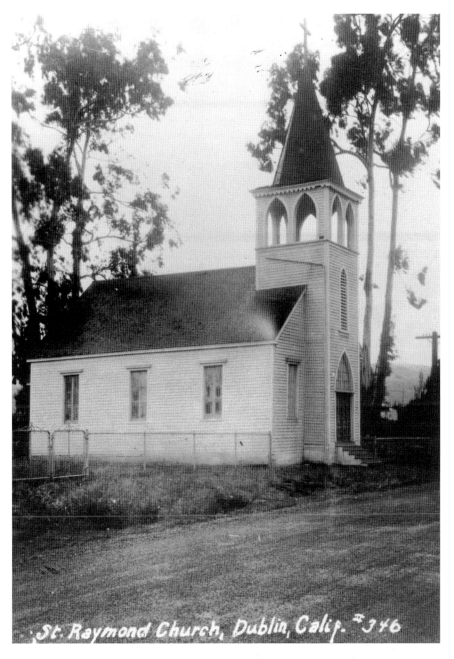

St. Raymond's Church has been at the same location since its construction sometime before 1857. *Dublin Heritage Park & Museums.*

Murray and Jeremiah Fallon left Ireland in the spring of 1834.[29] The Irish Potato Famine did not start until 1845 and lasted until 1849.[30]

Many California history texts describe the horrific story of the Donner Party and its terrible fate crossing the Sierra Nevada mountains in 1846. Local Dublin histories mention Jeremiah Fallon's traveling with others to try and save them. Fallon did not participate in a "rescue" attempt of the Donner Party during the winter of 1846–47. He was confused with another early California resident, William "Le Gros" Fallon. William Fallon lead a group to the Donner Party location in April 1847. That effort had more to do with "rescuing" the gold of one of the Donner Party's families than in rescuing any survivors.[31]

Then there are some questions that beg to be answered, even though they may never be. Why did the Murrays and Fallon leave Ireland? What convinced Eleanor and Jeremiah Fallon to give up their New Orleans shipping business to take a wagon train across the continent? Were the Fallons and Murray going to California or Oregon when they left St. Joseph, Missouri, on April 18, 1846? At that time, California was part of the Republic of Mexico, and the Oregon Territory northern border was only ratified by the U.S. Senate on June 18, 1846. Did they find out the United States declared war on Mexico (May 13, 1846) while they were in their wagons heading west? What made them proceed on from Fort Bridger when the Donner Party chose to stay and rest? Why did they head to Mission San Jose, which was no longer a mission then? Were they surprised when they arrived there on October 18 and found that California was already a United States territory?

These and other questions will probably never be answered. The Fallons and Michael Murray were not the kind of people who wrote much down. They were busy with their lives, which did not stop when they reached California.

PROMINENT EARLY SETTLERS

The Fallons and Murray were the pre–Gold Rush settlers most prominently featured in local stories and at the Dublin Heritage Park & Museums. John Green's story represents what post–Gold Rush settlers looked for in terms of opportunities. George Kolb and his family represent the mainly northern European settlers who came to Dublin in the late 1800s. Just like

the earlier settlers, he found Dublin to be a place where he wanted to settle and build his life.

Michael Murray became a prominent farmer and sheep rancher in and around the Dublin area. He married while living at Mission San Jose and went on to raise three children with his wife, Amelia. In 1852, he and Jeremiah Fallon bought one thousand acres from Jose Maria Amador. Michael Murray had enough local influence then that he was invited to work on a commission to set electoral precinct boundaries in the newly organized Alameda County in 1853. Somehow, he managed to get part of the new county named after him. Murray Township was one of the five original townships in the county. In a time with very few cities, or towns, townships were the only political entity in the heavily rural county. It roughly covered the entire southeast part of Alameda County. His influence seemed to dissolve rather quickly after that, as another Dublin landowner (James Witt Dougherty) became the first county supervisor when the supervisor form of government was instituted in 1855.

Murray built his house, which stood for many years, just to the southeast of what is now the intersection of Donlon Way and Dublin Boulevard. He and Jeremiah Fallon donated land for the construction of St. Raymond's Catholic Church around 1856, although James Witt Dougherty also claimed ownership to some of the land. The matter was eventually settled, and a cemetery for Catholics and Protestants was added behind the church. Murray was naturalized as a U.S. citizen on August 20, 1859. He was elected supervisor in 1860 and served until 1862. Michael Murray left ranching life afterward when he sold his property to another new resident to the Dublin area, John Green. Murray moved to San Francisco to become a real estate developer.

Jeremiah and Eleanor Fallon farmed the land and raised a family, which steadily grew. The children included Daniel, Catherine Mary, Ellen, William and Rodger Robert. All went on to marry local spouses and raise families. The Fallons built a house, which stood for many years, probably near what is now the intersection of Laurel Creek Way and Foothill Road in Pleasanton. Jeremiah died on September 5, 1864, and Eleanor acted as the executor for estate, which included 246 acres, 43 head of Spanish cattle, 960 head of sheep, 7 head of horses, 2 harnesses and 1 wagon. The estate was valued at $8,904, a rather prosperous farm at the time. Eleanor died on October 3, 1896. Decades later, the last remnant of the Fallon story was torched by mistake when local firemen burned down the derelict Fallon house on May 19, 1976.

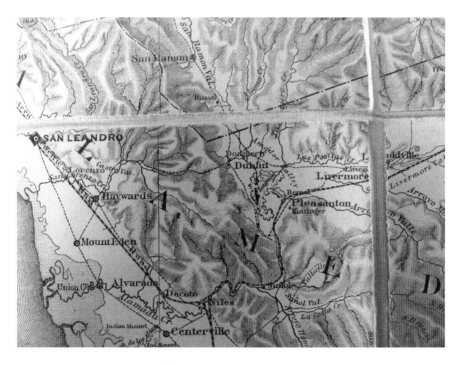

This 1873 topographical map of Central California excerpt shows Dublin along routes to Hayward to the west and Livermore and Laddsville to the east. *Oakland Public Library, Oakland History Room.*

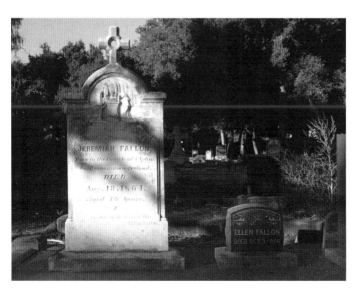

Jeremiah and Ellen Fallon rest side by side at Dublin Cemetery. Jeremiah died in 1861, and Ellen died in 1896. *Author's collection.*

Eleanor's great-granddaughter, Veronica Ellen Hilton Keifer, wrote down the stories her grandmother (Ellen Fallon Tehan, 1845–1928) told her about Eleanor and Jeremiah and family coming to Dublin. Those stories became the basis for much of the information included at the old Murray School House at the Dublin Heritage Park & Museums.

In 1857, John Green came to Alameda County. By 1860, he had accumulated enough cash to operate the general store on what was then the southeast corner of the crossroads. The roads included those leading to Stockton in the east, Sunol and Mission San Jose to the south, Hayward to the west and Martinez to the north. This was the same year the nearby St. Raymond Catholic Church was consecrated. John Green and his family prospered. He took on many occupations, including postmaster, rancher, general store and hotel operator. Green was elected Alameda County supervisor for Murray Township in November 1863 and stayed in office until 1867. He was elected supervisor again in October 1876 and stayed in office through 1882. In 1894, Green sold the general store to the Kolb family. By that time, he was recognized throughout the United States as a horse breeder and trainer. One of his horses, Directum, was known as the country's fastest trotting stallion in the mid-1890s.[32] In 1899, he built a large house next to the small original Murray home, which he had previously bought. Both buildings were just southeast of the general store and remained landmarks for many years. Green's store, used in many ways over the decades, still stands at the corner of Donlon Way and Dublin Boulevard. It is currently used as a church.

George Kolb was born in Munsterappel, about forty miles southwest of Frankfurt, in 1866.[33] He came to America in 1872 with his father and three older sisters. By the 1880s, he was working in Pleasanton at his brother Philip's general store. In 1894, he bought John Green's general store at the Dublin crossroads and started his family in 1896 after marrying Wilhelmina Hartung. It seems that owning the local general store also gave you a better chance of being the local postmaster, as he had that job as well for several years starting in 1896. By 1900, they had two sons, Edwin and Harold. Like most of the earlier settlers, he wanted to become a landowner and rancher. In 1904, he bought three hundred acres of land from Charles Dougherty and started his ranch. The land included property near the present Dublin Canyon Road intersection with Foothill Road and extended as far south as what is now Foothill High School. Ranch crops and livestock included grain, alfalfa, hay, tomatoes, apricots, sheep, chickens, horses, milk cows and beef cattle. By 1910, he was prosperous

enough to have a Craftsman-style home built on his land on the Dublin/ Hayward road. The Murray School was just across the road. George Kolb died in 1933, while Wilhelmina lived until 1952.

World War I even affected Dublin. George's son Edwin was drafted. There is no mention of how the Bavarian-born father thought about his son going back to Europe to fight Bavarians and other Germans. Edwin returned to Dublin around 1920. He soon married a local girl, Pauline Bernal. Meanwhile, Harold married Elsie Kroeger in 1920. Harold continued in the family ranching business while his own family grew (Donna, 1926; William, 1930; and Carol, 1938). After Harold suffered complications from an accident and poor subsequent medical treatment in 1941, son William ("Bill") increasingly took over the farm work. The three children all attended Murray School across the street. They went on to attend either Hayward or Amador High Schools.

These were just a few of the many settlers who came to Dublin in the late 1880s. The small farming community was focused around the

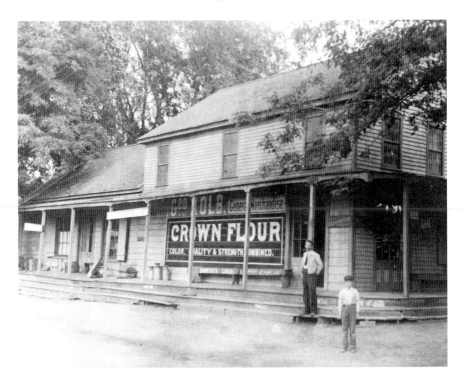

George and Edwin Kolb standing outside the general store at the Dublin crossroads in 1906. *Dublin Heritage Park & Museums.*

Stockton/Dublin/Hayward road and the Martinez/Dublin/Mission San Jose road. The Dublin social scene revolved around planting, harvesting, stock, births, birthday parties, business, travelers passing through, church and deaths. That scene included nearby families in Pleasanton, Livermore and Hayward, depending on where the local kids went to high school, and business relations. There were many other families—such as the Bonde, Cronin, Devany, Donlon, Fredericksen, Hansen, Koopman, Kroeger, McDermond, Rassmussen, Reimers, Tehan, Wells and Martin families— that had an impact on Dublin and the surrounding area through the late 1800s and the 1900s. We know something about them from Pleasanton and Livermore newspapers, old voting registries and school rosters. They are commemorated to some extent in the many streets and schools named after them during Dublin's huge growth after 1960.

It is unfair that we know little about the many other settlers and residents. There are just hints about Napoleon, Petra, Procopia and Melanie, who were noted as "domesticated Indians" (a category that year) in the 1852 Contra Costa County census. (Dublin was part of Contra Costa then.) Similarly, we know little about other settlers like the Costa, Friere, Geise, Schumer or Mirando families, who just appear as names on later censuses. And the stories of Chinese immigrants, such as You Ah, Yin Ah and Koy Ah (census taker's spellings), are lost too.[34] Similarly, we know little about the Japanese immigrants who were so critical to the area's agriculture. It's important to remember that Dublin's history only incompletely records the people who lived there. Many contributed to the story quietly, and we can only wonder what their lives were like and how they participated in the community.

James Witt Dougherty

James Witt Dougherty was one of the tens of thousands who came to California for gold. Later, he found the Dublin area and decided he could live well there. Unlike most others, Dougherty's story represents how a few settlers in California would greatly prosper from coming to the Dublin area.

As Beverly Lane, a local San Ramon Valley historian, noted, James Witt and Elizabeth Dougherty moved to the area in 1852, just before Alameda County was created out of Contra Costa and Santa Clara Counties. He partnered with William Glaskins to buy ten thousand acres of Amador's land for $22,000. He continued to buy additional land over

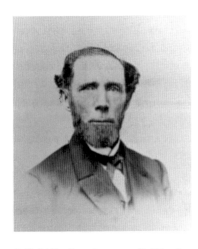

A Gold Rush emigrant to California, James Witt Dougherty went on to be one of the most influential men in the Dublin area. *Dublin Heritage Park & Museums.*

the years and became one of the largest landowners in Murray Township. At its largest extent, the Dougherty estate ran from just north of the Alameda Contra Costa County border, east into Dougherty Valley and south nearly to the Alviso Adobe Community Park in Pleasanton. Over the years, the Dougherty family had a huge impact on the growth (or lack thereof) of the area around Dublin throughout the late 1800s. James Witt Dougherty played a prominent role in local politics and was the Alameda County supervisor representing Murray Township for many years. The Dougherty family facilitated the introduction of the railroad from San Ramon to Livermore in the early 1900s and had much to do with later land sales.

James Witt Dougherty's history before Dublin seems like many others who came to California during the Gold Rush. He was born in Tennessee in 1813 and later moved to Mississippi. He seems to have operated or owned a few businesses in Hinds County, Mississippi, over the years that sometimes flourished and sometimes failed. In 1840, he had to sell three of his slaves to pay debts. He ran for county sheriff in 1843 and lost. He married and the couple had a son by 1844 and a daughter by 1845. He was elected probate clerk in 1846 but lost that election the next year. In 1849, he is mentioned in a letter as being in Panama waiting for a ship to California.

Dougherty made it to the California gold fields via Panama. It appears that the gold he found came from his business activities in Sacramento rather than mining. He and a friend from Mississippi, William Glaskins, worked for (or owned part of) B.F. Hastings & Company until late 1850. The *Sacramento Transcript* noted in December 1850 that they withdrew from the business "with a view of returning to their homes." Dougherty, wife Elizabeth and their family moved to the Dublin area in 1852. Dougherty and Glaskins paid $22,000 for ten thousand acres of Amador's land and became two of the largest landowners in Murray Township.[35] Dougherty eventually bought out Glaskins's interest and bought more land from Amador in 1857 and 1859.[36]

Dougherty and his family initially lived in Jose Maria Amador's two-story adobe house. In the August 1860 U.S. census, it appears the Dougherty ranch included ten people.[37] James Witt Dougherty identified himself as a ranchero whose property was worth $115,000 and who had personal property worth $71,000. His family included his wife, Elizabeth; his daughter, Ada (fifteen); and his son, Charles (twelve). Leopold Ries from Germany is listed as teacher. A.G. Taylor is the overseer, and there are four people listed as servants, a cook and a farmer.

As one of the largest landowners around Dublin, Dougherty wielded tremendous economic influence. He went on to leverage that into political influence. He was elected to be the Alameda County supervisor for Murray Township in 1855 and became chairman of the board that year. It should be noted that there were sixty-three voters in the township then. He remained a supervisor through 1860, with a one-year break in 1859.[38] However, he lost a bid to be state assemblyman in the September 1861 election.[39]

Other Dublin landowners and businessmen, such as Thomas Green and T.D. Wells, later used their influence to become county supervisors. For a time in the late 1800s, prominent Dublin landowners and businessmen were important figures in Murray Township and Alameda County politics. Dublin's county political influence waned as the century went on. Dublin's political relevance had pretty much vanished by 1902, when Murray Township was subdivided into two new townships. Dublin wound up as just another crossroads in the new Pleasanton township.

Also in the 1860 census and located near the Doughertys were the farms of the Fallons, McLaughlins, Holleys, Murrays, Martins, Darings and others. Sometime around 1860, Dougherty built a two-story wooden hotel at the Dublin crossroads. The hotel also housed the post office. However, the adobe house was severely damaged in an 1861 earthquake, and the Doughertys built a new wooden house soon after.

James Witt Dougherty died on September 30, 1879. He willed all his property to his son, Charles, and his wife, Elizabeth, except for some minor property to his grandchildren. His estate included eighteen thousand acres in and around Dublin both in Alameda and Contra Costa Counties. The land was valued at $550,000, and other property including crops, hay, implements and similar items was valued at $160,000.[40]

NAMING THE TOWN

There comes a time in a community when residents decide on a name for where they live. Sometimes names develop through common usage, or sometimes a situation or a person influences the decision. James Witt Dougherty seemed to be a person who had definite opinions on many things, and we can thank him for influencing the naming of this area.

How did Dublin get its name? The short answer is we don't know. Even as early as 1883, the *History of Alameda County, California* noted, "It is not precisely known how this place got its name."[41] But we do have some good stories and some good history that suggest how it might have been named.

One version of the story suggests that James Witt Dougherty inadvertently promoted Dublin's name. According to *Historic Spots in California*, when asked, Dougherty said the post office was called Dougherty's Station, but "since there were so many Irish living south of the road, they might as well call that part Dublin."[42] Some versions of the story have him saying "so many damn Irish," which is somewhat of an odd statement given that by 1880 most of the men working on his ranch grew up in Ireland. Another version suggests that the name came from Dougherty's cousin. The *Livermore Journal* described the event this way: "As J.W. Dougherty was walking with his cousin toward the present town of Dublin, his cousin asked, 'What is the name of this town?' Dougherty replied, 'It has no name.' His cousin then suggested, 'Why not call it Dublin since so many of the settlers are Irish?'"[43]

Another version says Dublin was named because of its hotels. At the intersection between the Martinez/Mission San Jose and Stockton/Hayward road, there were two hotels. Being across the road from each other and being a defining characteristic of community, the area became Dublin as a variation of "double inns." A similar story has the name of Dublin coming from travelers who had to double up in their hotel beds.

Still another version says that Dublin got its name due to preparations to haul wagons up the large hill just west of the crossroads. Drovers would stop, prepare their teams and "double" them up. This effort then led to the identification of the place as "Doublin'." Oddly, this spelling appeared much later in a 1914 newspaper map highlighting new roads that could be used for bicycle trips around Mount Diablo.

The crossroads for the Livermore/Hayward road and the road leading from Mission San Jose to Martinez had several names over time. There are no records of place names used by the local Seunen and Pelnen tribes. In about 1835, Jose Maria Amador had a ranch there, and so the names

This California state Highway 21 sign was located near what is now the corner of San Ramon Road and Dublin Boulevard in the late 1950s. *Dublin Heritage Park & Museums.*

"Amador's" or "Amador" became associated with the area. Somewhat later, "Amador Valley" began to be used, especially in the Contra Costa County newspaper. After James Witt Dougherty's arrival, Dougherty's Station post office was established in 1860 and lasted until a name change to Dougherty in 1896. The post office closed in 1908.[44]

Even as early as 1865, it appeared that there was some competition about what the area would be called. According to the *Daily Alta California*'s correspondent, "Six miles from the point where we entered San Ramon Valley we reach Dougherty's ranch, or Dublin, as the little village at the crossroads has been named."[45] The *Contra Costa Gazette* described a robbery at John Scarlett's hotel, in Dublin, in late 1866. The largest landowner in the area, James Witt Dougherty himself, seemed a bit ambivalent about where he called home. He regularly traveled to San Francisco to conduct business from 1868 through 1872. Through 1871, he signed the hotel register as being from "Amador." After that, he variously listed his residence as Pleasanton, Dougherty's, Dougherty's Station and, once, Amador Valley.

The name Dublin eventually gained traction. A regional newspaper's 1872 article referred to "Dougherty's Station...or what is sometimes called Dublin."[46] By 1877, the *Livermore Herald* was using the term Dublin when

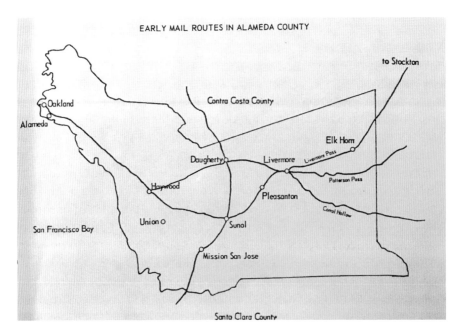

Dublin was a major point along early California mail routes. *Adapted from Western Express Research Journal of Early Western Mails.*

describing a new Sunday stage run from Livermore to Pleasanton, Dublin and Diablo.[47] Dublin can be found on the map, so to speak, in 1878. The name appears on the 1878 *Map of the County of Alameda*, published by Thompson & West.[48]

It appears that in the 1880s, most local papers and Alameda County used the term Dublin. There was a regular feature in the *Livermore Herald* by June 1882, "Dublin Items," that discussed events in and around the crossroads. In 1884, the Dublin Road District requested funds from the Alameda County Board of Supervisors for an improved bridge "on the road leading from Dublin to Livermore."[49] Another contributing factor may be that James Witt Dougherty died in 1879. With Dougherty gone, there was no one lobbying in favor of "Dougherty" rather than "Dublin." Throughout the late 1800s and early 1900s, Dublin was the predominant name used in newspapers and local discussions. It wasn't until another post office opened 1963 that Dublin became, in one way, official.[50] The issue was definitively concluded at the city's incorporation in 1982.

Dublin and Agriculture

Before it became known as the place that "grew" houses, Dublin had a reputation for growing crops. From the beginning, Native Americans harvested nuts, fruits, fowl and animals for food and clothing from the local environment. With the introduction of Spanish settlers into the area in the late eighteenth century, new methods of food production began. Along with cattle and sheep ranching, vegetables and fruits were grown in missions and pueblos around the San Francisco Bay Area. Cultivated vegetables and fruits were introduced into the Dublin area after 1826 by Jose Maria Amador when he settled here and expanded his Rancho San Ramon.[51] At one time, Amador owned thousands of acres, and his home included cattle, vegetable crops, workers and facilities to make farm equipment.[52]

Starting in 1849, tens of thousands of gold seekers came to California. Early farms in and around the old missions and ranchos grew and then sold crops to the huge influx of people. Farming, as an alternative to gold mining, became important in California's developing economy. Cattle ranching provided much of the beef sold in the mining regions.

The early farmers and ranchers continued the kind of agriculture first started by Amador. Michael Murray moved to Dublin, built a house and included an orchard on his farm.[53] This supplemented his primary occupation of sheep ranching. By 1853, James Witt Dougherty had focused his ranch on raising cattle and renting property out to other ranchers and farmers.

By 1856, it was estimated that there were as many as fifty thousand head of cattle and horses in Murray Township in addition to "immense bands of sheep in the hills and mountain."[54] In the spring of 1857, Joseph Black sowed four hundred acres of wheat on Jeremiah Fallon's property. Others sowed a similar amount on nearby Dougherty land.[55] By 1860, wheat acreage had increased by more than one thousand acres.[56] In the next year, additional land around Dublin and Livermore was added to wheat cultivation as more people began to take up farming.[57] Accelerating the change was a terrible drought in 1864 that resulted in the deaths of many cattle and sheep.[58] This contributed to a dramatic change in the local economy, as wheat as a cash crop began to compete with land used primarily for livestock grazing.[59] This, in turn, contributed to more people moving to the township.[60] The subsequent completion of the railroad through Livermore and Pleasanton and legal resolution of boundary issues in the Livermore grant led to even more people moving into the area.[61]

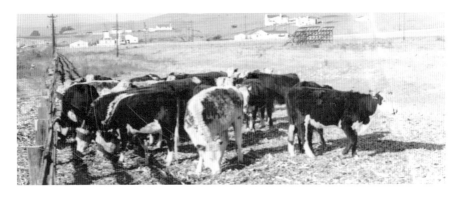

Grazing cattle near the original Santa Rita Jail near Highway 50. Cattle were an integral part of Dublin's agricultural and pastoral economy. *Alameda County Sheriff's Office Archive.*

The farmland between Dublin and Pleasanton were said to be the richest in the township, according to an 1876 book. Yields of seventy-five bushels to an acre suggested that this was very productive, compared to other parts of the county. "Wheat, barley, oats, hay, fruit and vegetables are now regularly grown, and the grape thrives well."[62] It was noted that Dublin had not grown quickly because much of the land was held by a few individuals who owned large tracts.[63] In 1877, a local newspaper commented on the "fields of barley in full head, and standing three feet in height" near Dublin.[64]

Through the 1880s and 1890s, agriculture in and around Dublin continued to change. By 1883, the area around Dublin included orchards and vineyards, along with fields planted in barley, hay and wheat. Sheep and cattle generally grazed in the hilly areas. Related activities included some dairy farming, and it was said that "nearly every farmer" kept fifty to five hundred hens.[65] An 1893 book describes several important crops in Murray Township but does not mention the Dublin area specifically. The many vineyards of Livermore Valley received extensive description, but it also mentioned almonds, prunes, peaches, pears, apricots and other fruits. Pleasanton was mentioned for its hops.[66] The book noted that cereal production and livestock continued and suggested that fruit and vegetable crop growth resulted in a more diversified agricultural environment.[67] Walnut and almond orchards were mentioned as well.[68]

In the early 1900s, grain was still a big crop in and around Dublin. That year, the crop output was less than earlier years due to a wet winter, which prevented some land from being seeded. The dry spring and a large demand for hay was also said to reduce the amount of grain cultivated.[69] Six acres of

land near Dublin produced forty-two tons of hay in 1908. This worked out to seven tons per acre and was considered one of the largest crops in years.[70] Sugar beets were mentioned as the crop along the Santa Rita/Pleasanton highway in October 1926. The beets were harvested and sent for processing at the Spreckels Sugar Company plant near Salinas.[71]

Dublin's agricultural economy continued with only some variation. Barley was grown at the Flanagan ranch near Dublin. The ranch was approximately where the Stoneridge Mall stands today. At that time, Dublin was considered to extend farther south than it does now. In promotional materials created by the County of Alameda, Dublin was recognized as an expanding area in 1937. The brochure proclaimed that "hay, grain and tomatoes are the principal crops of this community. Stock-raising is carried on extensively."[72]

Agricultural crime had always existed near Dublin. While there were early stories of cattle rustling, a new type of crime found its way into the news as crops changed. A newspaper reported 177 sacks of barley being stolen one night in July 1928. This might have had something to do with Prohibition and local moonshine operations.

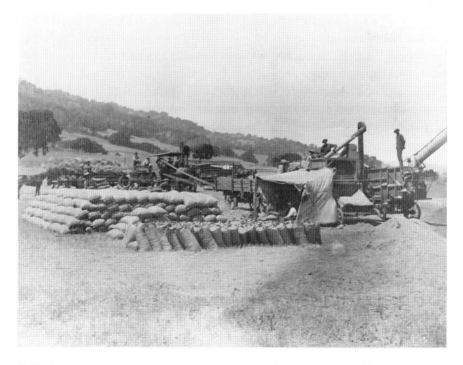

Gathering hay was a tremendous amount of work requiring men and machines. *Dublin Heritage Park & Museums.*

Before 1942, farming continued to be the area's main economic activity. Between Dougherty and Tassajara roads, there were many small farms growing various crops, among them walnuts, grain and hay.[73] Farms often kept chickens for domestic use and local sale. There were also dairies and farms that raised turkeys. The lands near what is now the Dublin Civic Center were known for raising beet and tomato crops.[74]

World War II saw the largest change in land use since the widespread introduction of planted crops in the 1880s. The U.S. Navy bought 3,396 acres between Dougherty and Tassajara roads in late 1942 to build two bases and a hospital. What had been mainly small farms and ranches became temporary homes and training areas for as many as seventy thousand men and women at any given time until 1946. This marked the area's change from agriculturally dominated land use to governmental, commercial and residential use. The days of farming and ranching were marked.

After the last sailors left in late 1946, some agricultural land returned to eastern Dublin. In 1947, the newly opened Alameda County Santa Rita Rehabilitation Center included agricultural job training and crop and livestock growing as part of its operations. In later years, up to 85 percent of Santa Rita's operating costs were offset by food and livestock production and sales. Over time, increasing jail populations and more stringent incarceration approaches reduced agricultural opportunities for prisoners.

In 1942, before the navy came to Dublin, this would have been a common view in what is now eastern Dublin. *Museum on Main, Pleasanton.*

The replacement jail opened in 1989, and all agriculture training and crop and livestock cultivation ended.

Ever since the widespread residential and commercial development started in the early 1960s, agriculture in Dublin has been a marginal activity. Cattle and sheep still graze in the western and northern hills, but increasingly this is a way to manage weeds and less as a commercial agriculture activity. The agricultural history of Dublin continues now primarily in books, articles and the occasional backyard garden.

The New Town of Dougherty

The increasing use of the name Dublin and the expansion of agricultural production led to a new opportunity for the Dougherty family to reinforce its prominence in the area. Maybe the Amador Valley needed a railroad and a new town to support new residents and new businesses.

Dublin had lost out to Pleasanton, Sunol and Niles in the competition for railroad service by 1869, when the first transcontinental railroad arrived in Oakland. While a right-of-way through Dublin Canyon appeared feasible, the route through Niles Canyon seemed to require less engineering and therefore less cost. At least one newspaper correspondent attributed Dublin's lack of growth through the late 1800s to losing the railroad. That did not stop some Dublin residents from thinking about a different rail connection to handle the agricultural crops and increase land values.

As early as 1874, James Witt Dougherty met with a group of Contra Costa County landowners to plan the incorporation of a new railroad that would run from near Martinez to San Ramon. The plan was to have it eventually connect to Pleasanton.[75] Since an earlier 1868 effort to fund a standard-gauge railroad had failed, this effort focused on the cheaper alternative of a narrow-gauge track. This effort, too, ended in failure since the landowners could not come up with sufficient funding. James Witt Dougherty's quest to get a railroad through his lands ended when he died in September 1879. It would be up to his son, Charles Medley Dougherty, to try again.

Charles Medley Dougherty played a role in the successful negotiations leading to the construction of a railroad through the San Ramon Valley in 1890. After negotiations between Contra Costa County landowners and the Southern Pacific Railroad, most landowners agreed to donate land to the railroad to get its agreement to build a standard-gauge railroad from Avon

(near Martinez) through Concord, Walnut Creek and into San Ramon. Dougherty and other owners south of San Ramon knew that Southern Pacific would eventually extend the railroad to connect to its tracks in Pleasanton. Construction through to San Ramon was completed in May 1891, and the first official trip took place on Sunday, June 7, 1891.

"Eventually" turned out to be eighteen years later. Negotiations between Contra Costa and Alameda County landowners and Southern Pacific took place from 1903 through 1906. This time, though, Charles Medley Dougherty and landowners got paid for their land. Charles Dougherty and other landowning relatives got more than $8,341 (in gold coin) for their land. Building began along what we now call the Iron Horse Trail in September 1907. Freight service began soon after, but passenger service only started in February 1909.

One of the conditions for the branch line negotiated by Charles Dougherty called for the construction of railroad sidings at a specific location on his old land. This was part of his plan to subdivide and develop a new town, Dougherty. Popular thinking at the time was that railroads

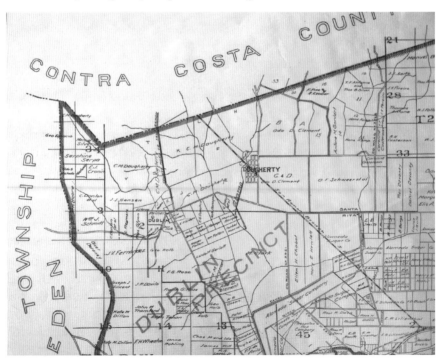

In this 1914 Dublin map, the planned town of Dougherty is seen near the center. There is no evidence that anyone lived there full time. *Oakland Public Library, Oakland History Room.*

brought prosperity and opportunities. As one of the largest landowners in Murray Township in Alameda County, Dougherty probably thought a new railroad stop on the new railroad branch would bring a golden opportunity to build a town around the transportation of local agricultural products to the rest of the state and country. Concord, Walnut Creek and Danville had prospered from their railroad connections since 1891. A similar result should be possible with the Dublin connection to points north and south. Dougherty built the siding and laid out a town around it.

The town of Dougherty was appropriately registered on official Alameda County documents and subsequently appeared on maps for much of the twentieth century. While there are reports of livestock corrals being constructed there, there are no reports of any house or business ever being built. Since Dougherty registered the town site with the County of Alameda, the name regularly appeared on maps, even though there were no buildings or streets. Through many revisions over many years, county, U.S. Geological Survey and private maps often showed Dougherty located just north of Highway 50 (later Interstate 580) and Dougherty Road. Even into the twenty-first century, the ghost town of Dougherty still appears on some online maps.

Lois Jordan and Dublin's Depression (1929–39)

The Great Depression hit Dublin and the Tri-Valley hard, but not perhaps as hard as other locations. Agricultural goods dropped in price, so farmers made less money. But they could still grow food and share within the small communities. Traffic along what was by 1927 U.S. Highway 50 diminished in direct proportion to California's and the nation's economies. The local gas stations and garages took a hit, but there was always some traffic traveling the roads. A new wave of settlers began to arrive in the Tri-Valley and in California.

Nearby, the cities of Pleasanton and especially Livermore began to deal with increasing numbers of homeless and jobless people. Being along the railroads, "hobos" riding the rails established camps outside the rail yards. For once, the railroads became more of a burden for the towns and less of a benefit.

Worse off were cities such as San Francisco and Oakland. Large numbers of sailors and longshoremen were out of work as West Coast and

international trade collapsed and the Depression spread across the world. Relief efforts were limited and usually inadequate. They were often led by local community groups such as churches and private efforts. These usually proved inadequate. But by late February 1933, a colorful San Franciscan had brought her efforts to the Dublin area.

In early 1931, Lois Jordan decided to do something for the hungry, destitute sailors and longshoremen on the waterfront in San Francisco. She made the rounds of local restaurants and groceries, asking for their cast-out foods. She took what she could beg from them and passed out food in an empty lot across from Pier 23. During one of those early efforts, she was reported to feed 2,500 men. A pioneering newspaper feature writer started writing articles about the "White Angel" and her work. Reports about the efforts appeared in San Francisco and the Bay Area, as well as newspapers as far away as Wisconsin. From cast-aside food she branched out to getting donated clothes and gave it all away to the crowds that would appear at the "White Angel Jungle." The "Jungle" was a term used to describe the encampments set up by hobos throughout the country. Eventually, used tables, benches and kitchen equipment arrived for her and her helpers to use. For more than two years, she made her daily rounds and wound up gathering supporters, promoters, detractors and thousands of hungry people. Besides food and clothes, the Jungle operated as a labor exchange where local employers could hire day labor. In a self-written book in 1935, she claimed to have fed 110,000 men in one four-month period. In January 1933, the appreciative men presented her with a thirty-six-foot sailing boat they built. They christened the boat *Kama* after the Hindu god of love.

By February 1933, the experiment in social services had ended. Depending on the source, the experiment ended for any number of reasons, including Jordan's exhaustion. Some said it ended because other sources of charity had developed to meet San Francisco's needs. Others suggested that the associated fights, brawls and petty criminality at the Jungle proved too much for the local authorities to take any longer. In her book, Jordan suggested that the inauguration of Franklin D. Roosevelt on March 4, 1933, and his subsequent efforts, meant that other people were taking up her cause more effectively than she could.

San Francisco's loss was Dublin's gain. In March 1933, newspapers started reporting that the White Angel had a new mission. Saying that she was "sick and worn out," the reports noted that she was moving to her farm near Pleasanton. The *Livermore Journal* reported that Jordan purchased twenty acres of land to employ and train out-of-work men to raise food to be sent

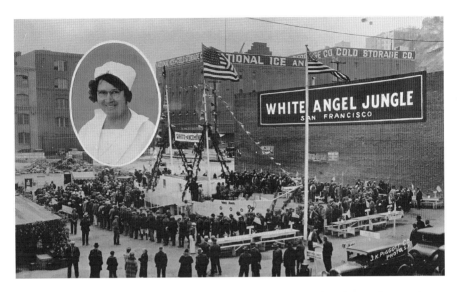

Lois Jordan, the White Angel, became quite the celebrity in San Francisco and across the country before moving to Dublin. *San Francisco Public Library.*

to the cities. A new effort would be started to get local communities to put boxes on the outskirts of their towns to hold bread and food. The intent was that hobos would find food outside towns and would, therefore, not go into town and scrounge food. The *Journal* noted that she and her sister were on a trip from Tracy to Vancouver, British Columbia, to set up a bread box at each town on the way to Canada.[76] She soon became a speaker at local Pleasanton and Livermore church services. She invited the local populace to Easter Sunrise services that year, and 150 attended.

In an interview with *Livermore Journal*, the journalist described Jordan in the following way:

> *The speaker, known to thou*[sands as the] *"White Angel" greeted my companion and myself with a smile of welcome as she met us at the gate of her home in the foothills of Pleasanton township Sunday noon. She was garbed in spotless white. Her cheeks were smooth with a pink glow in them; eyes bright and good humored; her hair entirely concealed beneath a white covering. Her manner was brisk, but not abrupt, with a homely cordiality in it.*[77]

She described her mission to the writer: "Three years ago the desire for money left my life and love entered. Since then I have been devoting

my life and my energy to helping humanity. I ask nothing for myself. The homeless and helpless men who have been reduced to poverty by the depression need me."

The newspapers don't indicate what the residents thought of the newcomer and her efforts on the farm. Ada Dougherty Clement, one of the largest local landowners, seemed to be impressed with Jordan's efforts, as she sold her the land for ten dollars in May 1933.

Jordan didn't stay out of the news long, even when she took a trip on her sailboat to Tahiti. When she arrived there in August 1933, she found a cable awaiting her stating that all was not right at her farm. The report indicated that one of her workers had sold her cow and pigs, burned some of the farm buildings and taken off with her furniture in her automobile. Arriving back by steamer in September, her story took another strange twist. The *San Francisco Chronicle* reported her surveying the damage and saying, "I still can't lose faith in humanity." The *Oakland Tribune* reported that nothing was wrong at the farm and that things worked well in her absence. The *Pleasanton Times* reported only that Jordan was planning a harvest celebration. It did mention that "she declares that she has not lost faith in humanity, and despite set-backs which her venture received during her absence, she still plans to carry on."[78] She surely had a tough year, which ended with her breaking both ankles during a fall at the farm.

The year 1934 saw Jordan in the news again and apparently still trying to run her farm. In May, she sent out invitations to her neighbors for a rodeo. In August, she was run off her farm by one of her workers. Once again, different newspapers reported different details, with one stating she was chased off her property by a man with a bayonet. On August 11, Joe Vuisto (or Guisto) was arrested for disorderly conduct. The year ended badly, with Jordan reporting that she had been robbed of $600 cash in a San Francisco store.

After that, Lois Jordan began to disappear from Dublin and local history. For a while, she was remembered because there was a White Angel Road in Dublin. But by March 1936, she had sold the farm and moved on. She resurfaced when her efforts to help the poor in 1939 were mentioned in a San Francisco newspaper article. She was using her home for a grocery store in the impoverished Hunters Point neighborhood of San Francisco. She again received notice in a November 1942 newspaper article, in which she offered her help to win the war, although it mentioned she was in poor health. Lois Jordan, Dublin's nationally renowned social service volunteer, died on April 28, 1949, in San Francisco.

Other Developments in the 1930s

Despite the general economic depression throughout the United States, California and the San Francisco Bay Area, Dublin and the local area continued to see some development. Electrification that had started during the early 1900s continued to follow the roadways. Early telephone systems started in towns and villages as early as the late 1800s. They grew from just a few connections put together by entrepreneurs into larger and larger systems through expansion, foreclosures, acquisitions and consolidations. Locally, a farmer's telephone line became operational in the Amador-Livermore Valley area in 1932, with one of the connections being the Green Store in Dublin. A local newspaper later claimed that it was the first public telephone system in the area. As late as 1985, two of those original four telephone lines still operated.[79]

The Third Wave of Settlers: Volk McLain and San Ramon Village

Between 1957 and 1960, Volk McLain Communities Inc. researched where to build its next big residential and commercial development.[80] Known as one of California's largest residential development firms, it chose the vast open agricultural lands near Dublin. In March 1960, it decided to purchase 4,500 acres from 17 different owners for a master planned community that would be known as San Ramon Village. Through June, it finished negotiations and Alameda and Contra Costa County requirements for the project. About 98 percent of the property was zoned when ground was broken for the first relatively inexpensive homes in early July. The advertising slogan was "City Close, Country Quiet" for homes priced about $14,000. On the grand opening weekend in September, the developers hosted more than ten thousand visitors to view the models on Hillrose Drive, the only paved street in the development. They sold 98 homes. The developers staged a huge public relations event on November 3. A long caravan of moving trucks drove through East Bay cities on their way to deliver 40 families to Dublin. By December 31, San Ramon Village had 1,296 residents in 374 houses.

Besides homes, the San Ramon Village Shopping Center started to take shape. Safeway was the anchor store to the open-air shopping center located near the center of the subdivisions near the Alameda and Contra border.

Dublin residents showed pride in their community over the years. This float at an unknown event featured Irish dancers. The rocket states, "Dublin keeps pace." *Dublin Heritage Park & Museums.*

During this period, Volk McLain worked to transform the Parks Community Service District into the Valley Community Service District. The district originally started in 1953 but remained inactive until 1960. The district would eventually provide many of the services usually provided by cities. A $4 million bond was issued to construct the infrastructure needed to support the new homes and businesses.

The year 1961 was a busy one. The developers sold the Murray School District a new 11.6-acre school site in February. Safeway opened, along with other businesses in April. The Valley Community Service District bought its first fire station site on Donohue Drive in August. It would soon house a three-engine station. In September, the developers sold to Murray School District Dublin's first swimming pool site. The developer then donated a $95,000 community pool. What was heralded (by the developer) as the world's most modern sewage treatment plant started operation in October. The 20.8-acre, $1.5 million plant could serve up to 16,000 acres in the new

community. Nearby and just across the county line, the San Ramon Country Club Park "middle income" development, oriented around a planned golf course, opened in November. By the end of 1961, 841 homes had been sold. The population had grown to 3,364.

Rapid growth continued through 1962. The Murray School District bought a 15-acre parcel for a second school. The Valley Community Services District bought 3.3 acres for new well sites and a water storage site. In May, the San Ramon Country Club opened with a nine-hole golf course, a driving range and a swim and racquet club. June saw the American Lutheran Church buy 3 acres. By the end of 1962, 1,188 homes had been sold. The population had grown to 4,752.

Businesses and others came to the new community as well. In January 1963, another Lutheran church bought 5.6 acres, while Mobil Oil Company bought a site for a service station. The active adult community Sunny Glen opened in June. It offered an activity center, homes and apartments. The same month, a twelve-unit "campus style" apartment complex opened on Starward Drive. In some ways, it looked more like an old-style motor court than anything related to a campus. Murray School District purchased a thirteen-acre school site in August. September brought Dublin something it had not had since January 1908: a post office. The informal name of San Ramon Village finally went away officially in

The Briarwood

A 3-bedroom version of the Better Homes & Gardens award-winning 1294 plan. The same fine features of the 4-bedroom model are evident throughout this home; the master suite with private bath, Mr. & Mrs. closets and built-in vanity, the dining room and well-separated family and living rooms.

Plan 1293

One of the models near Amador Valley Boulevard for the Villa de San Ramon development. This model sold for $21,800 sometime in the early 1960s. *Dublin Heritage Park & Museums.*

September when the local post office opened as the Dublin Post Office. The San Ramon Country Club stables also opened that month, and the first horse show opened in November. Television reception in the area was terrible until a local cable system constructed antenna and wiring. The year ended as another developer bought some of Volk McLain's remaining land. And, of course, another service station site, this time for Union 76, was bought in December. By the end of 1963, 1,800 homes had been sold. The population had grown to 7,200.

Housing and businesses kept coming to San Ramon Village, which was still the name used for the growing community. Shuffle board, lawn bowling, swimming, square dancing and crafts at the Sunny Glen adult community engaged the residents there. Around the area, parties and fashion shows were the focus at the San Ramon Swim and Racquet Club. The Redi-Room and 19th Hole were popular gathering places at the golf course. Other families started and maintained the new "Miss San Ramon" and "Mrs. San Ramon" events. By the end of 1964, 2,669 homes had been sold. The population had grown to 10,676. Dublin's unrelenting growth continued through 1965 and 1966.

From the very first plans, Volk McLain realized that additional roads would benefit its investment. The Dublin location was chosen in part because it was adjacent to Highway 50, the main connecting road to Hayward, Oakland and the East Bay. In 1966, it sold the State of California 138 acres for a freeway right-of-way right through the middle of the development. In March, the Interstate 680 groundbreaking ceremony took place. This made the area even more desirable since it allowed easy and rapid freeway access to San Jose and Martinez. In April, the Amador Valley Joint Union High School District bought a 45.6-acre site for its second facility, Dublin High School. Murray School District bought its fourth elementary school site (12.3 acres) the same month. Alameda County Flood Control started a $1.6 million project to build canals and storm drains to contain water and storm runoff as well. Safeway Stores Inc., another church and another developer bought more land during the last part of the year. Murray School District ended the year by buying another elementary school site (12.31 acres). By the end of 1966, 3,677 homes had been sold. The population had grown to 16,446.

Another advance in a growing community awareness was started around 1966 as the "Maid of Dublin." Between 1966 and its cessation in 1979, more than fourteen young women competed to become a spokesmodel for Dublin. Throughout the period, the Maids could be seen and photographed

The Maid of Dublin and other community notables celebrate Dublin's first stoplight at the corner of San Ramon Road and Amador Valley Boulevard in 1972. *Dublin Heritage Park & Museums.*

at public and commercial events, like the opening of stores, parades and even the unveiling of the first stoplight in Dublin. The Maid of Dublin seems to have fallen out of relevance by the late 1970s with the dawning awareness that it could be interpreted as demeaning and exploitive to women.

From that point on, Dublin remained a promising location to develop. The State of California completed Interstate 680 in November 1967. This modernized the north–south and east–west highway connections that had always made Dublin a crossroads. The new freeways made Dublin an even more desirable destination for living, commuting and shopping. The area west of Interstate 580 became the next development area. By the time much of the area was built out in the 1980s, development had begun to move to the eastern side of Camp Parks. Dublin's incorporation in 1982 brought development authority to residents and their locally elected representatives rather than distant county officials. From then until now, housing and shopping development moved relentlessly east along with the expanding city

boundaries. By 2018, the population of Dublin had grown to more than sixty thousand.

By 1968, there was a bewildering list of developments in Dublin. There were Briarhill, Silvergate, Appletree, Pleasant Ridge, Barkley Square, Villa de San Ramon, Ecco Park of San Ramon and Summerhill, just to name a few. Growth was so rapid that at one point one development along Village Parkway was just called "Number 3732." They were matched with at least three shopping centers: San Ramon Village, Dublin Square and Town Center. They would all be followed by many more.[81]

It's important to note that Dublin's residential, commercial and (less so) industrial development were part of the larger Tri-Valley development. San Ramon, Pleasanton and Livermore were all going through their growth spurts. In general, what started in Dublin kept growing because cheap land, good transportation linkages and a rapidly growing migration from the San Francisco area all found the Tri-Valley to be a good alternative for living and doing business.

More houses, more businesses and more amenities developed or changed through the late 1960s and 1970s. And some of Dublin's history went away. Elementary, middle and junior high schools opened, closed or changed composition. Dublin got a drive-in and bowling alley. The Foremost Dairy Research Center opened on Dublin Boulevard. A new St. Raymond's Catholic Church opened on Shannon Avenue. The Amador–Livermore Valley Historical Society received the original St. Raymond Church to restore and preserve it. The Alameda County Library came back to stay when the Dublin Public Library (portable) opened on Vomac Road.[82] Kolb Park, perhaps the first park in Dublin, opened. The last of the old pioneer homes (Murray/Green House) burned down. The State of California opened Interstate 680 complete with ribbon cutting and a parade on the new road.[83] Dublin High School was established in the fall of 1968 as the second high school in Amador Valley Joint Union High School District.[84] Crown Chevrolet opened on Dublin Boulevard. Valley Community Services District built Shannon Community Center.[85] Kentucky Fried Chicken and Foster Freeze restaurants were built on Amador Valley Road. By 1968, one estimate claimed that Dublin had about seventeen thousand residents. An indoor theater opened in Dublin. The brand-new Dublin High School opened on Village Parkway. And then, on top of all the changes, the vocational school for disadvantaged youth (Parks Job Corps Center) opened and then closed at the old Parks Air Force Base site.[86]

The 1970s continued growth and adaptation. New middle schools opened to deal with the aging student population. Old St. Raymond's Church at the Dublin Heritage Center received a new steeple as part of its restoration. In the Murray School District, children at one school chose the name "Donlon" for their school's permanent name. The Dublin Public Library moved into new and larger quarters on Village Parkway.[87] The lord mayor of Dublin, Ireland, and his wife visited Dublin, California, as part of a sister city arrangement. A new estimate said the population of Dublin was 13,641. In June 1971, Dublin High School graduated its first senior class.[88] Mervyn's Department store opened, and Dublin got its first elevator. Casper's Hot Dog restaurant opened the next year. The first stoplights were put up in 1972, and another city incorporation effort started. In 1974, Dublin voters created a special library district to expand the Dublin Public Library. The growing community got a new, larger swim center on Village Parkway next to Dublin High School. The U.S. Department of Justice opened a federal correction institution near Camp Parks.

By 1975, the Bay Area Rapid Transit (BART) buses began service from Dublin, Pleasanton and Livermore to Hayward and Bayfair Stations. A roller skating rink opened in the original Safeway store building on Amador Valley Boulevard, and an ice skating rink opened in a new building on San Ramon Road. Caltrans started widening Highway 580. Concerned citizens started the Dublin Historical Preservation Association (DHPA) to save the original Murray School (then located on Dublin Canyon Road), which was at risk due to highway construction. Caltrans donated the building to DHPA. It was moved to stand next to old St. Raymond's Church near the Dublin Pioneer Cemetery, and the area became the Dublin Heritage Center in late 1976.

Through 1976 and the end of the decade, Dublin continued to grow and change. Even the weather contributed to new and unusual events when a heavy snow fell in and around Dublin. As part of a training exercise, local fire departments accidentally burned down the Fallon House, one of the last pioneer family homes. Another city incorporation effort started and failed in 1977. The Valley Community Services District changed its name to Dublin San Ramon Services District.[89] To respond to increasing demands, the Dublin Public Library moved to a new, bigger building on Amador Valley Boulevard in 1979.[90]

The 1980s were some of the most momentous years in Dublin's history. In 1980, Camp Parks was deactivated and then reactivated as Parks Reserved Forces Training Area. Dublin had at least 45 bars and restaurants, 14 gas

stations, 34 auto repair shops, 550 to 600 local businesses, 13,496 residents, 3,644 single-family homes and 480 multiple-residence units. It seemed as if it was time for Dublin to become a city. In November 1981, Dublin residents, on their third effort, voted to incorporate as a city. On February 2, 1982, Dublin became a city.[91] Pete Snyder was elected the city's first mayor. Soon thereafter, Dublin got its own zip code (94568). Komandorski Village, a low-income housing project that included the last of the World War II–era buildings in the city, was demolished. A new low-income housing project (Arroyo Vista) started construction to replace it.

Schools closed or were repurposed, and new businesses started operating or closed their operations. In 1988, the elementary and high schools were unified as the Dublin Unified School District. The Dublin Senior Center opened in the old Fallon School multipurpose room. The City of Dublin started to provide its own parks and recreation activities by taking control of the Dublin Sports Grounds and Shannon Community Center. New and larger business started to open around the city when a GEMCO and Ross Store opened. Dublin's attempt to broaden its tax base by being an industrial hub started to fade away, as only a few light industries moved to the new city.

Dublin began to come of age with incorporation and more and more residents. The County of Alameda opened the new Santa Rita Jail, which replaced the decrepit and unsafe jail near Tassajara Creek and Highway 580. The Dublin Civic Center opened on Dublin Boulevard in September 1989, and Dublin city activities moved out of a strip mall. As the new city continued to expand, it replaced its old community center with a new one at Shannon Park. In 1994, Dublin lost the last of the World War II buildings. An auditorium used for children and adult community sports on Camp Parks burned down in a massive fire that was seen for miles throughout the Amador and Livermore Valleys. As the new millennium approached, it seemed that Dublin's history would continue down the path of ever-greater growth and expansion.

Taking Stock of Dublin's History Up to 2000

While the Native Americans have pride of place for being the first to live in Dublin, each of the subsequent groups left a legacy that lives on today. The Mexican settlers left us many place names, and their legacy can be seen in street names such as Amador Valley Boulevard and school names such

as Amador Elementary. Michael Murray, Eleanor and Jeremiah Fallon and other Irish American settlers left us many more landmarks, including school names (Murray Elementary and the various Fallon school names over the years) and the Fallon Sports Park. The very name of Dublin refers to the legacy of the number of families that shared a common Irish origin. James Witt Dougherty (who reputedly referred to himself as an American and not of European lineage) and family also gave us street and school names. The name of the never-built town of Dougherty still shows up on paper and online maps. The later northern European settlers gave us such names as Kolb Park. The World War II and later military settlers left Camp Parks and some generally unrecognized street names. Few people realize that Arnold Road was named in the 1950s. The U.S. Air Force and Parks Air Force Base replaced the road's initial navy admiral name and renamed it after U.S. Air Force General Henry "Hap" H. Arnold. And Volk McLain and later developers' impact can be seen all over, from Vomac Road (a combination of the names Volk and McLain) to Enea Plaza, Sorrento and many other later housing developments. The settler legacy is all around us. And through it all, there grew a community that evolved into a dynamic city, with its share of benefits, shortcomings and challenges. It can be expected that the legacy of twenty-first-century settlers and their backgrounds will continue to be interesting and exciting.

Chapter 3

WE JUST PASSED THROUGH HERE

THE PREDECESSOR ROADS: TRACKS, PATHS AND TRAILS

Tracks, paths, trails, roads, highways and interstates connect and influence people and communities. Dublin's location and history are due in large part to the fact that it was located at the intersection of two major routes, one going north–south, the other going east–west. The stories of how roads developed had, and continues to have, a dramatic influence on the community. From the earliest times of Native Americans to today, roads are an intimate part of Dublin.

The Amador and San Ramon Valleys, with their trees, bushes, springs and marshes, provided food and water for Native Americans who lived there. Anthropologists and archaeologists believe there was an early trade between coastal and inland areas for obsidian, flint, salt, furs and seashells (including abalone). It is likely that the valleys included trails to and from the northern San Francisco Bay and to the large marshes in the Livermore Valley. This route connected with local villages and paths to the east in the San Joaquin Valley.

The first written mention of the paths through the San Ramon and Amador Valleys appears because of Spanish explorer Pedro Fages's journey in 1772. Fages and his party traveled south from what is now Antioch along a route similar to that which would become Highway 21. Before and after that

event, any number of Native Americans used the paths and trails. As the late 1700s moved into the early 1800s, Spanish and then Mexican soldiers and ranch hands gradually and periodically ventured into the valleys. With the establishment and development of Mission San Jose, Native American workers conscripted into the mission sometimes herded cattle and sheep throughout the Amador and Livermore Valleys. From the 1810s to the 1840s, paths northward from Mission San Jose also saw much use by non-mission Native Americans who raided the mission herds and periodic Spanish (later Mexican) military incursions seeking to prevent or retaliate after the raids. The mission lands were given over to local private parties starting in 1834. By then, much local traffic resulted from products going to or coming from Jose Maria Amador's rancho located in Dublin or Robert Livermore's rancho. Amador's rancho produced cattle, horses, leather and other products. Amador's products primarily went to other ranches and settlements around San Francisco Bay and San Jose, although some products probably went to the early American ships trading out of San Francisco.

As Michael R. Corbett noted in his *Historical and Cultural Resource Survey of East Alameda*:

> *As the area grew, trails that connected the ranchos were expanded into roads capable of carrying freight wagons, carriages, and horse and buggy traffic. In addition, new roads were constructed during this period. In 1853, the county built a wagon road through Niles Canyon....By 1857, primitive roads linked the sites of future towns in the valleys. They also lead westward through Hayward Pass and Mission Pass to the flatlands along the bay, northward to the San Ramon Valley and Contra Costa County, and eastward through Livermore Pass, Patterson Pass, and Corral Hollow Pass to the Central Valley....The network of roads was not engineered but followed the topography.*

THE EAST-WEST ROAD: FROM THE STOCKTON ROAD TO THE LINCOLN HIGHWAY TO INTERSTATE 580

The most critical road to Dublin's history was the one that went from the San Francisco Bay to the California Central Valley. The Native Americans first established the route to trade seashells and flint. The Spanish and Mexican residents used the trail to move cattle and hides to landing and

trading points along the bay. Later travelers used it as a land route to the Sierra Nevada Mountains and gold. Then it became a wagon road to move freight from parts of the Amador, Livermore and San Ramon Valleys to the developing San Francisco, Oakland and bay side communities. Goods flowed back along the same route. Originally a dirt path, it developed into a hard-packed, dirt road and then a privately owned planked toll road before reverting to a public road. From the late 1800s to the twentieth century, the east–west road grew in size, use and importance.

The east–west road from the San Francisco Bay toward the Central Valley ran through what eventually became known as Dublin Canyon (or, if you were from Hayward, Hayward Canyon). It may have started as a Native American trail linking interior tribes with the Bay Area. Early California maps show a trail or road from the San Francisco Bay through the canyon in about 1848 and as the Gold Rush continued. It's possible that it was an alternate route to the gold fields, although most "49ers" traveled via boat up the Sacramento River or on the roads from Alviso through Mission San Jose and Livermore to Stockton.

Many early California maps show a route through Dublin Canyon. Soon after Alameda County was formed, James Witt Dougherty petitioned to operate a toll road over part of the route through the canyon from Hayward to Dublin. He upgraded the road by adding planks and charging users for the improvements. He may also have started running a stagecoach service over the road. There are many references to stage services through Dublin over the years, with the various hotels offering food and rest. Dublin served as a stagecoach stop to connect travelers to the San Jose/Martinez route. There is no record of when the toll road ended.

Official efforts to maintain or improve roads and bridges were the responsibility of local road districts. They were some of the first organized efforts after Alameda County was formed. Road districts could tax residents to pay for the work. As another option, residents could decide to work on the roads for three days each year. Alameda County records don't say how often residents paid a fee instead of working. County board of supervisors' minutes and newspaper articles often describe residents petitioning for road or bridge improvements. It seemed that the bridges over Tassajara Creek usually needed repair after winter and spring rains. Newspapers often commented on county efforts, or lack of effort, to fix the bridges. In April 1889, residents appealed to the board of supervisors for help. Residents Dougherty, Green, Kelly, Kelly, Donlan, Devaney, Fallon and Campbell sent a letter to the board stating, "The present bridge on said creek is now in a

dangerous condition and is likely to drop down at any time, the same having been erected 15 years ago, and is not safe to cross over." William Campbell Sr., the Dublin Road District overseer, reported on the bridge's condition. He concurred that the bridge was not only unsafe but also needed to be four feet longer and three feet higher.[92]

Sometimes the roads were in good condition and busy. In 1860, the road was well used, and a trip down it sometimes mentioned no problems. For example, the *Daily Alta California* reported in 1856, "The distance to Hayward, through Dougherty's Canyon, is ten miles, with pleasant scenery all the way,"[93]

During this period, many local stage lines operated in California. They came into business quickly and often failed just as quickly. Dublin became a stop along the route to rest and water horses, discharge and take on passengers and freight and address passengers' needs. Whether a stage line lasted often depended on it having a contract to carry the U.S. mail. That contract was usually the only consistent revenue a stage company received. Matthews and Hilton, J.A. Talmadge, Moore Brothers, Duncan Cameron and Charles McLaughlin were just a few of the people who ran stages from Oakland to San Jose and through Dublin Canyon to points east.[94] By 1865, trains started operating along the East Bay and connected San Francisco, Alameda and Hayward. Some stagecoach lines went out of business, but others wound up connecting the outlying communities to the train lines. Even though the transcontinental railroad service started in the early 1870s through Livermore, Pleasanton and Niles Canyon, stage service was still necessary between Hayward, Dublin and the communities in the San Ramon Valley. One example is Feely's stage service that operated daily from Danville at 6:00 a.m., traveled through Dublin and arrived in Hayward in time for the 9:00 a.m. train to Oakland and San Francisco. The stage then turned around and went back to Danville.[95]

Dublin was a key point on the stage route and on the roads that serviced the local area. The 1867 *Pacific Coast Directory* noted that Peter Donlon owned the Amador Hotel and the stage line between Dublin and Haywood (as Hayward was known at the time). The directory listed a blacksmith, postmaster, Bamber & Company Express agent and wheelwright. To support the travelers and the local farmers, Lengfeld & Shiman and John Green provided general merchandise.[96]

By 1884, the road's dangerous aspects had become legendary. A correspondent from the *Livermore Herald* made a point of mentioning it in one description of a trip from Hayward:

About 1 o'clock we left this contented little place and turned in the direction of Dublin, which could be seen in the distance. As we rode down Bulmer Hill, the recorder of time seemed to read off the long list of fatal accidents that have taken place here. Many a careless driver has paid the price of his life on this spot. The fatal accident to the four-horse stage twelve years ago, driven by Oliver Perkins, is the darkest stain. Of late, however, few accidents occur. It is a very innocent-looking hill and the slope quite gentle, the road averaging about 20 feet in width.[97]

The accident mentioned happened in June 1869. An overloaded stagecoach with twenty-four people onboard traveled to Dublin. Just after reaching the top of Bulmer Hill, the driver lost control when the brake failed, and the horses started galloping down the road. The stage overturned, and as the *Marysville Daily Appeal* reported, "[a]ll the passengers on top, fifteen in number, were thrown forward with great violence upon the ground....The stage rolled over several times with its load of human freight, wounding and mangling those inside in a frightful manner." The driver and two passengers were killed, and all the survivors were seriously injured.[98] Following that terrible accident, authorities started grading away the hill. Despite what the *Livermore Herald* noted in 1884, there would be more accidents over the years that would keep highway officials cutting the road over the hill down again and again.

Through the end of the 1800s and the early 1900s, the road handled passengers, freight, cattle and sheep drives, bicycles and then automobiles from San Ramon and Dublin to Hayward or the Central Valley. In 1877, there was a proposal to build a narrow-gauge railroad through Dublin Canyon to handle the traffic.[99] The *Pacific Rural Press* mentioned the Eden Grange proposal to build a narrow-gauge railroad "connecting with the narrow-gauge road now under process of construction immediately to the west of Haywards [as the city was named at the time]." The railroad never got built.

Through the 1880s, traffic ebbed and flowed along the route, usually known as the Stockton Road. Transportation businesses came and went as well. The *Livermore Herald* noted in 1882 that "the Dublin stage has stopped running, and the mail is now carried on horseback."[100] Dublin's general stores, black smithies and hotels continued to service the traffic along the road and offered respite for travelers and livestock. The road continued to be mainly dirt, with some sections having a semi-hardened gravel service. Dust in the summer and mud in the winter coated the road at different times of the year.

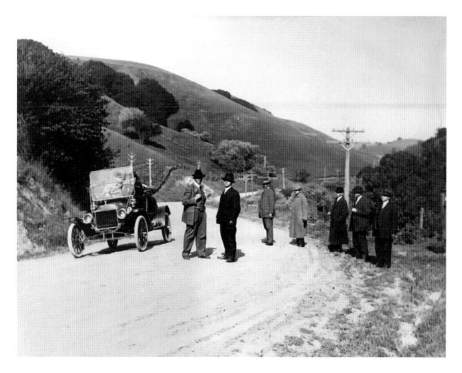

A group of early automobile enthusiasts enjoy a break from their drive and the scenery in Dublin Canyon in the early 1900s. *Livermore Heritage Guild.*

The early 1900s brought the beginning of a dramatic change that would signal the resurgence of the highway. Automobiles begin to be mentioned in May 1895. The *San Francisco Call* published an article titled "A Horseless Epoch, Electricity Will Soon Drive the Useful Animal Off the Street." The actual introduction of automobiles to the San Francisco Bay Area took longer, and it wasn't until about 1900 that they are mentioned in San Francisco.[101] Dublin resident H.W. Kolb said the first automobile came into the Amador Valley in 1906. However, there was a mention of an automobile scaring a horse and causing an accident in Hayward as early as November 1899.[102] The *Livermore Herald* mentioned Dr. W.S. Taylor getting his car in June 1903. Traffic along the road just kept getting faster and more congested from then on.

Like most other Alameda County roads, the Dublin section of the Hayward/ Stockton route continued to be a county responsibility. Roads and bridges still got fixed only when the residents, not the traveling public, complained enough for the county board of supervisors to allocate some money.

Starting in 1913, the Lincoln Highway route was being laid out from New York to San Francisco. It was a private promotional effort to call for the first transcontinental highway. It had no federal or state monies allocated to its construction. This resulted in many sections between towns that had no paving. Advertising material for the route across the country mentioned Dublin as one of the many way points and service stops on the way to San Francisco. While the road from Stockton through Livermore and Dublin to Hayward had always been important locally, the Lincoln Highway project suggested that the road could grow to have statewide and even national significance.

On September 5, 1919, anyone at the Dublin crossroads around noon would have remarked at the long line of seventy or so dusty army trucks, automobiles and motorcycles driving by.[103] They had started in Stockton earlier in the day and were headed for Oakland, with their destination being San Francisco. Among the many men in the convoy was Lieutenant Colonel Dwight D. Eisenhower. He and the other men were on the last legs of the first U.S. Army transcontinental motorized road trip. During their 3,251-mile Lincoln Highway trip, they found out that it took two months to cross the country and that the army and the country had much to learn about building roads and highways. Railroads were much faster. The trip made an indelible impression on the young Eisenhower. In 1967, he said, "A third of a

A car speeds westward on the Lincoln Highway (Dublin Boulevard) past the Dublin crossroads in 1932. *Dublin Heritage Park & Museums.*

Lieutenant Colonel Dwight D. Eisenhower participated in an epic army transcontinental trip. The convoy drove through Dublin on the Lincoln Highway on September 5, 1919. *Dwight D. Eisenhower Presidential Library.*

century later, after seeing the autobahns of modern Germany and knowing the asset those highways were to the Germans, I decided, as President, to put an emphasis on this kind of road building."[104] Eisenhower was a major proponent for the passing of the Federal-Aid Highway Act of 1956, the beginning of America's interstate system. The interstate system would have a defining effect on Dublin.

Throughout the 1910s, automobiles and trucks became cheaper to buy and easier to operate. Local farmers and merchants then had better, quicker ways to move their goods and services to local markets and the Greater San Francisco Bay Area. It was around this time that the railroad's dominance for trade began to decline in the area.[105] The route lost some celebrity in 1927 when the Lincoln Highway was realigned away from Dublin and Stockton to a route through Berkeley, Richmond and Vallejo to Sacramento.[106]

Dublin, the Highway and Prohibition

Prohibition came into effect in and around Dublin in January 1920. While there isn't much in the record about the opinions either for or against outlawing alcoholic beverages in Dublin, there were activists both in favor and against in Hayward, Pleasanton and Livermore. It wasn't until the appointment of Earl Warren as Alameda County district attorney in 1925 that serious enforcement began.[107] Castro Valley became known for bootlegging, the small-scale production and distribution of alcoholic beverages. Enterprising distillers had operations throughout the region, including one seized in Walnut Creek.[108] Being on the major road connecting the San Francisco Bay Area to the interior of the state made the Dublin crossroads a major transit point for illegal liquor. It also gave the local hotels and restaurants easy access to liquor, if they wanted it.

Apparently, they wanted it. On January 18, 1922, California state prohibition agents arrested six men and two women and seized liquor valued at $33,000 in several locations in the southern end of the Bay Area. In that raid, they seized $15,000 worth of liquor at the Dublin Hotel alone.[109]

The next day, the prohibition agents loaded the seized liquor onto a truck to take back to San Francisco. During the day, agents Drumhansl and Shurtliff were delayed by telephone calls purported to be from their

supervisor recommending they avoid attention by driving back after dark. Meanwhile, the agent's supervisor received anonymous telephone calls warning him his agents would be hurt if they continued to be "too active." Back at the hotel, one of the agents was approached by a man who suggested that it would be to the agents' benefit if they didn't hurry while loading the truck. Afterward, as the agents were driving east through Dublin Canyon, a "big motor truck with six men in it" tried to crowd them to the side of the road. The agents "drew their revolvers, and when the liquor bandits learned they were ready for a fight they dropped their attempt."[110] The same article indicates that the prohibition agents decided that from then on, they needed to be better armed as they went about their business. Sawed-off shotguns were ordered for their future use.

The battle between prohibition agents, local restaurants, backcountry distillers, bootleggers, rival gangs and others continued until Prohibition's repeal. Illegal liquor production and distribution stopped being a problem in 1933, when the Twenty-First Amendment was ratified and Prohibition was repealed throughout the United States.

By 1925, the U.S. government was highlighting the importance of the Lincoln Highway as a national transportation route. The road going through Dublin was incorporated into the new highway system as Highway 50. A *Hayward Daily Review* article noted that the Santa Rita/Dublin highway was California's second state highway built with concrete.[111] The roadwork took place in the summer of 1927.[112] The State of California now took notice of the road's importance and confusingly gave it an additional name (State Highway 84).

Sometimes the road just brought strange situations to Dublin. In 1924, an Alameda County dispute between the Milk Producers Association and the Milk Dealers Association spilled over to the foot of Bulmer Hill, just west of the Dublin crossroads. After a tip-off to the Livermore police, four Pleasanton youths were arrested as they attempted to hijack a milk truck from Tracy. They told the officers they intended to dump the milk on the roadside. After that, Alameda County sheriff Barnet posted deputies on each milk truck until the "Milk War" ended.[113]

Poor roads occasionally had other benefits, at least for the garage owners. The *Hayward Daily Review* said it best when describing one weekend's work in February 1930: "The Dublin canyon road was a prolific source of revenue for garages…Sunday. Dublin and Livermore garages were kept busy pulling out cars which had gotten on the dirt

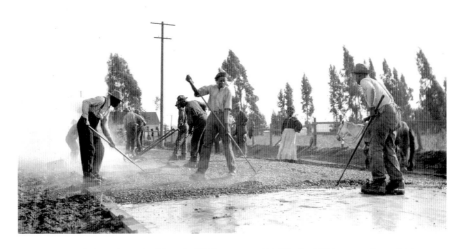

Early road building along the Lincoln Highway near Dublin in 1914 meant lots of labor. *California Department of Transportation (Caltrans).*

shoulders of the road and stuck. At $1 a tow, profits accumulated for the garages."[114]

The Dublin Highway received periodic upgrades over the years. In late 1931, the state highway department devoted $630,000 to pave six miles. The newspaper report implies that it was newsworthy when part of the highway got paved at all.[115]

The January 1933 *Livermore Journal* noted that reconstruction would start on the Dublin Canyon highway to shorten distance and remove elevations and turns. "More than six miles of highway, reaching from the top of Castro Hill into Dublin, are to be rebuilt....One of the largest of the new cuts will take the road along the hillside north of Canyon Inn, eliminating the present steep approach up Castro Hill. Another large cut will extend for several thousand feet north of Dublin, where the road will cut through the hill and eliminate curves north of the Dublin school house."[116] The paving company rented space at the Dublin Canyon Inn, a well-known restaurant and one of the several motels between Dublin and Hayward.

Throughout the Depression, road traffic slowly increased along Highway 50 and roadside business picked up. During the summer of 1934, more than five thousand cars per weekday drove through Dublin. On Sundays, more than nine thousand cars drove through Dublin. During the winter, six thousand cars drove through on Sundays and

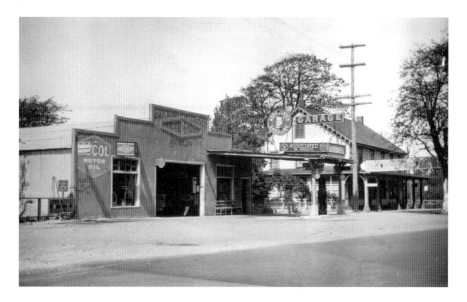

The Ericksen and Nielsen Amador Garage on the Lincoln Highway would have been one of several Dublin garages benefiting from accidents along the highway. *Dublin Heritage Park & Museums and Online Archive of California.*

four thousand on weekdays.[117] Gas stations and garages dotted the road between Hayward, Dublin and Livermore. For a long time, you could find a few gas stations leading out of Hayward, with only one or two between there and Dublin. The three gas stations in Dublin handled traffic stopping at the bottom of Bulmer Hill or going north or south along Highway 21. Niedt's Teepee diner took advantage of its iconic two-story stucco building, and its location on the corner of the two highways, to lure travelers in for gas and food. Just a mile or so away from the Dublin crossroads, you could find a garage, wrecking yard and gas station at Wood's Corner near Dougherty Road. Joyce's diner was just down the road, and so was the trucker's bunk house. There were more gas stations to the east. Farther down the road, Duarte's gas station and garage in Livermore serviced local and highway traffic. While gas was cheap, cars built in the 1920s and 1930s often needed the many gas stations and garages along Highway 50.

Continuing its long recognition as the major east–west route and now part of U.S. Highway 50, the route through Dublin received detailed description in an important Depression-era road atlas. *California: A Guide to the Golden State*, one of the American Guide Series books completed by the Federal Writers' Project, Works Progress Administration, mentioned

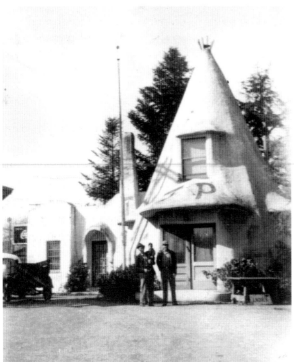

Above: Before paving, Dublin Canyon Road could be dirty and dusty. This image shows the road sometime in the early 1900s. *Dublin Heritage Park & Museums.*

Left: The Niedt family's iconic teepee-shaped diner took advantage of traffic at the intersection of Highway 21 (San Ramon Road) and Highway 50 (Dublin Boulevard). *Dublin Heritage Park & Museums.*

Highway 50 and the interesting aspects of the various towns along its way. In the 1939 edition, Dublin had more prominence than Pleasanton or San Ramon. Unlike other routes at the time, U.S. 50 from Carson City, Nevada, to San Francisco was said to be "paved roadbed throughout… excellent route for trailers."[118] The guide gives Dublin its own entry, which describes the history of the village of two hundred people, mentioning Jose Maria Amador, James Witt Dougherty and one of the stories about how Dublin got its name. St. Raymond's Church and Jeremiah Fallon's house received mention as worth noticing before heading west along U.S. 50 to Hayward.

World War II brought huge stresses on the United States highway infrastructure and San Francisco Bay–area highways and roads. Dublin became a hub for military and naval traffic. Situated at the crossroads of Highway 50 and California State Route 21 and with railroad connection north to Martinez and south and east to Pleasanton, Livermore and the rest of the country, the area around Dublin was ideal for locating bases. Between 1942 and 1943, the navy finished constructing three naval bases just east of Dublin and a Naval Air Station just east of Livermore. The huge amount of construction traffic was followed by huge numbers of navy buses, trucks and automobiles. Hundreds of thousands of personnel cycled through the Dublin navy bases by 1946. Nearly all of them, and all the supplies they used, arrived via trucks and buses on Highway 50. And that doesn't include the tens of thousands of military and civilian vehicles that came over the road traveling to or from all the military and naval bases and cities in and around San Francisco.

By the end of the war, two-lane Highway 50, and all the other nearby roads, were worn out. The State of California and the U.S. government started repairing and expanding the roads as soon as budgets switched from a wartime focus to a postwar rebuilding focus. The period from 1951 to 1953 became a pivotal one in Dublin's history. Before 1950, Highway 50 helped integrate Dublin with the rest of the Livermore Valley and California. After 1953, Dublin became more easily and quickly connected via the four-lane expressway to the whole San Francisco Bay Area.

By 1950, as many as eight thousand vehicles a day passed through the Dublin crossroads on two-lane Highway 50.[119] Starting in 1951, the State of California began plans to widen the road into a four-lane limited-access highway with fewer crossing points. Not quite a freeway, the new Highway 50 would speed travelers and freight to and from the San Francisco Bay Area to the Central Valley and beyond. The work was

For most of its existence, Highway 50 was a two-lane road. This 1953 photograph shows the typical post–World War II traffic on the highway. *California Department of Transportation (Caltrans).*

completed by 1953. One of the immediate consequences was to make the traditional Dublin community smaller. For decades, the area to the south of Dublin Boulevard along State Route 21 (also known as Foothill Road) usually thought of itself as part of Dublin. Murray School, the old Fallon House and many farms now found themselves cut off by the new highway. Crossing all four lanes of the increasingly busy highway at grade (that is, with no overpass) was often dangerous and sometimes nearly suicidal. Eventually, all the land south of Highway 50 became part of Pleasanton.

Through the 1960s and 1970s, Highway 50 received several upgrades, eventually resulting in a four-, six- and then eight-lane freeway. It resulted in ever faster and easier drives between San Francisco, Oakland and the hinterlands. Added to that easy drive were the ever more affordable houses being built throughout the San Francisco Bay Area. Dublin and the development that started in it in 1960 was a perfect example of that. By

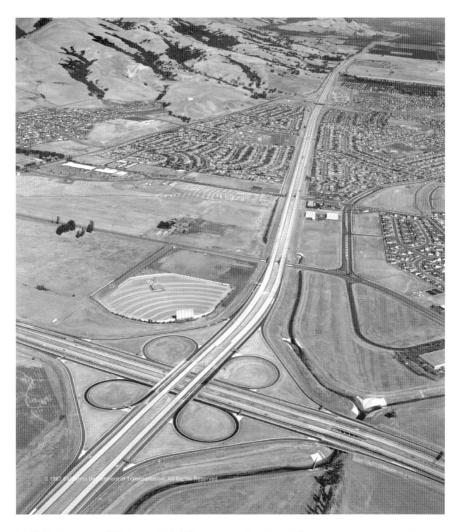

In 1967, Interstate 680 through Dublin was completed, and there was a new connection with Highway 50. The empty land quickly filled in with businesses. *California Department of Transportation (Caltrans).*

1967, Dublin received another important highway connection when the last link of Interstate 680 connected Highway 50. Just a few years later, in 1973, Highway 50 became Interstate 580.

THE NORTH–SOUTH ROAD:
FROM COUNTRY ROADS TO INTERSTATE 680

The other defining road in Dublin history ran north–south. It connected Dublin to Contra Costa County and the small farm towns to the north. Farther north, it connected to Martinez and San Francisco Bay, both of which allowed travelers access to Sacramento and Northern California. Toward the south, the road connected Dublin to the small farm towns such as Sunol and Pleasanton and onward to Mission San Jose and Santa Clara County.

For thirty-two years, from 1935 to 1967, the road that linked Walnut Creek, Alamo, Danville, San Ramon, Dublin, Pleasanton, Sunol and Mission San Jose, California, was named Highway 21. In Alameda County, this road has many names. At different points, it is now known as "San Ramon Road," "Foothill Road," "Pleasanton Sunol Road" and "Mission Road." In Dublin, people now call it San Ramon Road. Before the construction of Interstate 680, most people and most maps identified it as Highway 21 or, more accurately, "State Route 21."

In 1853, at the formation of Alameda County, part of the route from Mission San Jose, "thence through Amador Valley, and known as the Stockton Road," was declared a public highway. Throughout the second part of the 1850s, agricultural products and their transportation dominated the Alameda County roads running north and south through the valleys. There were few farms with only about two hundred people in and around Dublin and outside Pleasanton. The late summer season often saw the biggest traffic as huge horse-drawn threshers serviced the valley and hill fields. They were followed by wagons hauling the wheat and hay to Pleasanton or sometimes Hayward. As fruits and vegetables and orchard crops gradually replaced wheat, hay, cattle and sheep, the products sometimes were shipped to the new railroad branch line, which terminated in San Ramon in 1891.

The late 1800s and early 1900s saw intermittent traffic growth along the road. Horses, carriages, hay threshers and wagons were the main traffic. Generally, traffic increased as the weather improved over the course of the year, with the heaviest use being around harvest time. Throughout these years, Dublin grew slowly, as farms tended to become more numerous but smaller in size. Vegetable, orchard and hops crops became more numerous, and the importance of getting them quickly to market increased. The farms along the road from San Ramon, Dublin, Pleasanton and Sunol continued to send their crops along the road until it reached the Dublin crossroads.

This is the typical condition of local roads leading to, or from, Dublin in about July 1912. *Museum on Main, Pleasanton.*

From the crossroads, freight and people went west to market in Hayward or southeast to Pleasanton or east to Livermore.

Just a few miles south of the Dublin crossroads, there began an early housing development that brought lots of traffic through Dublin. In the 1890s, Phoebe Apperson Hearst began work on a great estate. The Hacienda del Pozo de Verona grew to include multiple buildings, including a three-story, fifty-room mansion with an indoor pool on a five-hundred-acre estate. Mrs. Hearst entertained on a grand scale. Her parties included the wealthy and the prominent. Some of the guests included presidential candidate William Jennings Bryan, the king of Belgium, future president Herbert Hoover and the son of the founder of the Bahá'í faith. For several years, she entertained the entire University of California graduating class for an evening of dinner lectures and sport. One of her largest events took place in 1912, when three hundred delegates to the YWCA summer camp stayed on the grounds. The Hacienda events had a big impact on local traffic until it closed upon Mrs. Hearst's death in 1919. The estate grounds eventually became the Castlewood golf course and country club.

The changes in how guests came to the Hacienda reflected growing importance of roads and, incidentally, crossroads such as Dublin. While in the 1890s guests arrived at the Hacienda's own railroad station, by 1910 limousines, cars, trucks and buses began to replace horses, carriages and wagons. And while dirt and gravel generally worked well enough for horse-drawn vehicles, especially in the late spring, summer and fall, as more and heavier cars and trucks started to use the roads, better construction would be crucial.

In August 1928, the Mission road, as the road from Sunol to Mission San Jose was known, was scheduled to make its first transition from dirt to improved road. As was mentioned in the *Livermore Journal*, "Oiling of the Mission road will be of great importance to motorists traveling from Livermore to San Jose." At a time when many roads were still dirt, putting down a coating or two of oil cut down on the dust and (to some extent) improved the road surface.

The *Pleasanton Times* discussed road improvements in a detailed April 26, 1929 front-page article:

Roads to Be Repaired
Following out the program of improvements promised before his election,
Supervisor Ralph V. Richmond has introduced and has adopted by the
Board of Supervisors, resolutions providing for the pavement of the Foothill

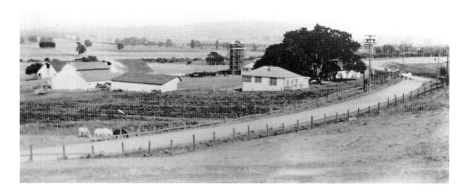

This is what the road looked like south of Dublin and west of Pleasanton. The Meadowlark Dairy is pictured here in about 1923. *Alviso Adobe Community Park and the Museum on Main, Pleasanton.*

> *road from Dublin to Sunol....Foothill road, leaving Dublin, skirts the foothills of this valley, passes the Castlewood Country Club, three miles from Pleasanton and winds its picturesque way over the hills coming out near the entrance to Sunol glen at Sunol. The road carries heavy traffic and has been in poor condition for some time....The road is used as a direct highway for those journeying from San Jose and points south through to the San Joaquin and Sacramento valleys. Traffic during the summer months is particularly heavy.*

Automobile and truck traffic was still sparse then. By 1934, there were still only about two cars per minute using Highway 21 going north out of Dublin. The Depression had an impact on agricultural, commercial and casual travel.

Despite its tardy entry into the list of numbered state routes, the road became significant enough to receive detailed description in an important Depression-era road atlas. As described earlier, *California: A Guide to the Golden State* gave mention to the Dublin-Sunol road just as it described the U.S. 50 highway. The following excerpts, with some historical inaccuracies, describe roadside venues in Alameda County in 1939.

> *DUBLIN 15.4 m., is at the junction with US 50.*
> *DUBLIN, 52.7 m. (367 alt., 200 pop.), is in a valley visited in 1811 by Jose Maria Amador, a young private in the San Francisco Company. Later, while major-domo at Mission San Jose, he drove the mission flocks and herds onto it. In 1834, [in] recompense for his military services, he was*

granted 16,517 acres. For a decade, Amador's adobe served as an inn on the Hayward-Stockton road to the mines, becoming the nucleus of a village. It is said that the village was christened Dublin by James Witt Dougherty, who bought the Amador house in 1852. Asked by a stranger what the place was called, he replied that the post office had been designated Dougherty's Station, but since there were so many Irish there, the settlement might as well be called Dublin. The name stuck. Dublin is at the junction with State 21. Left from Dublin on State 21, along the base of the Sierra de San José at the western edge of Livermore Valley, to St. RAYMOND'S CHURCH, 0.1 m., dating from 1859. The JEREMIAH FALLON HOUSE (L), 1 m., was erected in 1850 of timbers cut from the San Antonio redwoods and of lumber brought around the Horn. Beneath a giant oak tree (L), 3 m., is the ALVISO ADOBE, built in 1845 by Francisco Alviso, major-domo of Rancho Santa Rita. The well-preserved BERNAL ADOBE (R), 3.5 m., was constructed in 1852 by Augustin Bernal, one of the grantees of Rancho el Valle de San José.

World War II had its impact on Highway 21, just as it had an impact on all roads and highways in the San Francisco Bay Area. The biggest change occurred in and around Dublin and Pleasanton. Starting in 1942, the navy built three sprawling bases housing more than seventy thousand sailors in hundreds of barracks and buildings in what had been empty fields. Camp Parks, Camp Shoemaker and Shoemaker Naval Hospital had a huge impact on travel in the Tri-Valley. Suddenly large naval vehicle convoys appeared on the two-lane roads. Jeeps, trucks and buses took sailors from the bases north along Highway 21 to the Port Chicago Naval Magazine or Benicia or Mare Island Naval Shipyard. To measure the impact of this traffic on the roads, the state highway authorities started counting military vehicles on Highway 21 in 1942. On one day in July, 161 military vehicles drove north along the highway. The traffic only got busier after that.

Local traffic along the highway also increased. The highway took thousands of Seabees (Naval Construction Battalion sailors) to and from Mount Diablo for work and naval exercises. And the road handled everyone who got jobs building the bases or providing goods and services to the facilities. The first local housing crunch started as construction workers and naval families flooded the area looking to live close to work or their loved ones. As one measure between 1942 and 1946, an estimated 350,000 naval personnel came through Fleet City. And many of them journeyed along Highway 21.

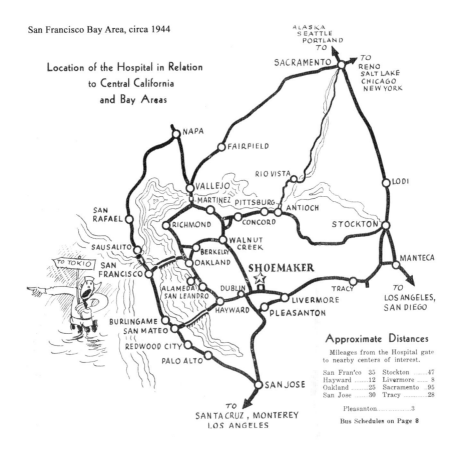

San Francisco Bay Area, circa 1944

Location of the Hospital in Relation
to Central California
and Bay Areas

Approximate Distances

Mileages from the Hospital gate
to nearby centers of interest.

San Fran'co 35 Stockton47
Hayward12 Livermore 8
Oakland25 Sacramento .95
San Jose30 Tracy28

Pleasanton................3

Bus Schedules on Page 8

Shoemaker was the short-lived name given to the area encompassing Camp Parks, Camp Shoemaker and Shoemaker Naval Hospital during World War II. *Author's collection.*

After the war, traffic along Highway 21 increased steadily in line with economic and population growth. In July 1946, there were on average five cars per minute, every minute, traveling north out of Dublin. By 1947, it was seven cars per minute. In 1952, it reached ten cars per minute. For the rest of the 1950s, the average stayed around nine or ten cars per minute until 1957, when it reached eleven. That meant, on average, more than fifteen thousand cars were traveling north out of Dublin every day. It seemed as if a new highway was needed.

From 1951 through 1959, the U.S. Air Force conducted basic training for recruits at Parks Air Force Base in Dublin. The air force built barracks, buildings and offices on the same location as the navy's World War II Camp Parks. Nearby, the County of Alameda opened the Santa Rita Rehabilitation

Center and county work farm in the navy's old disciplinary barracks at Camp Shoemaker. Between the two, there were many thousand more cars, trucks and buses using nearby Highway 50 and Highway 21.

The 1960s started with a series of housing and shopping developments that changed the nature of the Tri-Valley. By the end of the decade, Dublin alone had transformed from a small farming crossroads with a few hundred residents to a burgeoning suburb with hundreds of houses, thousands of new residents, several new shopping centers, new elementary schools and a new high school. Pleasanton went through similar growing pains. A devastating 1969 fire destroyed most of the old Hearst buildings and disrupted operations for a while at the Castlewood Country Club. In time, it was rebuilt and again added traffic to the road.

In 1962, the views along Highway 21 at the intersection with Alcosta Boulevard started to show evidence of many new housing developments in and around Dublin and San Ramon. Stop signs increasingly gave way to traffic lights. Dublin's fist traffic light was installed on San Ramon Road at the intersection with Amador Valley Boulevard.

The biggest change to travel along Highway 21 happened when Interstate 680 replaced the old route in the 1960s. The old heavily congested two-lane road became a modern four-lane (and eventually much wider) freeway. The opening of Interstate 680 in Alameda County took over two years, with individual segments being opened at different times. The first segments opened on December 16, 1965, with great fanfare. The segments ran from Stoneridge Drive to Interstate 580 through Pleasanton and Dublin to Alcosta Boulevard. In November 8, 1967, a connection was made from Stoneridge Drive south to California Highway 84 near Sunol. The new interstate promoted tremendous residential and commercial growth in Pleasanton and Dublin after the 1960s.

While Interstate 680 dominated traffic use north and south, Highway 21 also started to grow from a two-lane to an improved four-lane highway. Its name lived on for a short while as a combined designation with Interstate 680. The somewhat clunky name Highway 21/Interstate 680 soon changed to just Interstate 680. Effectively, the short history of Highway 21 ended on November 8, 1967, when all the various pieces of Interstate 680 were linked and opened to traffic. During the next few years, parts of old Highway 21 reverted back to their 1800s names. Once again, travelers going north into Dublin drove along Foothill Road to San Ramon Road until they left Dublin and Alameda County and drove north on San Ramon Valley Boulevard to San Ramon.

This is the view along Highway 21 (San Ramon Valley Road) near Alcosta Boulevard. It shows the entrance to new early 1960s residential developments. *Caltrans and the Dublin Heritage Park and Museums.*

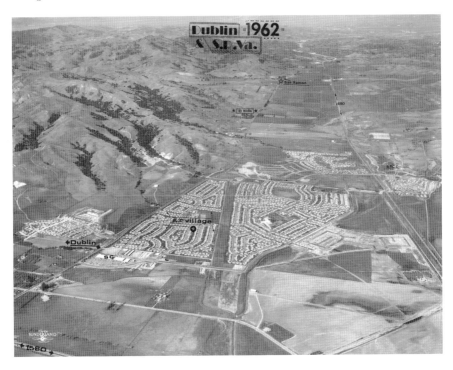

New housing developments in Dublin were designed around current and future roads. In 1967, Interstate 680 filled the gaps between neighborhoods. *Caltrans.*

The dramatic growth all along its route resulted in constant upgrades, lane changes, right-of-way changes, new traffic signs and additional traffic lights. In most ways, the roads were far better constructed and maintained than they had ever been before. Long gone now for most of the route are the towering trees that provided shade along the road. For a long time behind the Alviso Adobe Community Park in Pleasanton, there was a small piece of Old Foothill Road on the original route and in the original narrow two-lane condition. But that changed in 2018 when it became the Castleridge staging area for access to Pleasanton Ridge Regional Park.

The story of the north–south road is a story of growth over time, very similar to Dublin's overall history. Over the years, traffic grew dramatically just as Dublin grew. The California Department of Public Works estimated that by 1925, about 3 cars per minute went on the road north out of Dublin toward San Ramon and beyond. By April 2016, the average traffic per minute on San Ramon Road near Dublin Boulevard was more than 17. The average daily traffic count was 25,112 vehicles.[120]

STOPPING AND STAYING AWHILE:
LODGING AND DUBLIN

It can be said that along with roads, there must be places to stop, eat and sleep. For most of California's and Dublin's history, long-distance travel spanned several days or weeks. Since Dublin was a crossroads, it was only natural that restaurants and places to rest were built there. This is a short description of the lodgings that helped define the journey through Dublin.

Jose Maria Amador started building his rancho as early as 1826. He was noted for his hospitality, which was an important aspect of Californio culture. This was especially the case when there was nowhere else to rest when journeying. During the Gold Rush, his rancho hosted prospective miners on their way to Sierra Nevada along the route from Mission San Jose to Stockton and onward.

By 1860, travelers along the Hayward/Stockton Road gained a new option for resting. John Scarlett and his partner, Grandlee, opened a hotel at the Dublin crossroads. It came to be known as the Amador Hotel or Amador Valley Inn. Soon James Witt Dougherty opened his Dougherty Inn.[121] Since it was located at the crossroads of the Martinez/Mission San Jose road and the Stockton road, Dublin was the natural stopping place for

local stagecoaches, freight wagons and other travelers. Apparently, each of the hotel owners thought there was sufficient traffic for them to be successful. That probably changed dramatically in September 1869, when the Central Pacific Railroad opened for business in Pleasanton and Livermore. It dramatically changed the economics of freight and passenger traffic for the Amador and Livermore Valleys.

Dublin's hotels were simple, two-story wooden structures with a few small rooms. There are no written descriptions of the hotels and only a few photographs of later versions of each of them. Records show the Amador Hotel burned down at least once. And it's not clear if the later Dougherty Inn was the original structure or a replacement for an earlier building. We do know they stood across the road from each other near what is now the intersection of Dublin Boulevard and Donlon Way. Besides rooms, we know they offered food and drink, and each had watering troughs outside for horses.

Ownership, or at least operation, of the hotels seems to have been a lucrative activity. Local newspapers thought it newsworthy to report who ran the hotels as well as whether or not the hotels were busy. In 1872, there is a mention of Dublin having two stores, one blacksmith shop and two hotels. The papers reported that William Tehan "presided" over Green's Hotel and that Peter Luyten owned or operated Scarlett's Hotel by 1874. In 1882, it seemed newsworthy that John Green repainted and renovated the Amador Valley House in preparation for renting. The *Livermore Herald* noted, "It is a good business for some wide-awake person."[122] Showing that it was a competitive business environment, the newspaper reported that Mr. Marsh started painting and fixing his nearby hotel. It appears owners came and went and that by 1884 Captain Murphy was renting and running the Amador Valley House. The Marsh House was still operating nearby. Through the late 1880s, there may have been as many hotels in Dublin as there were in Pleasanton.

Business, and traffic, continued, but the advent of automobiles and trucks breathed new life into the Dublin hotel business. In 1914, there were still two hotels operating in Dublin. Arthur and Nell Reimers operated the Amador Valley Inn during the 1920s. However, in 1924, a federal court temporarily closed the nearby Dublin Inn for selling illegal liquor during Prohibition. In the 1930s, the two hotels operated beside the school, church, grocery store, blacksmith shop, library and five gasoline stations.

By this time, gas stations started appearing outside the crossroads and along U.S. Highway 50 heading to the east. The little gas stations and repair

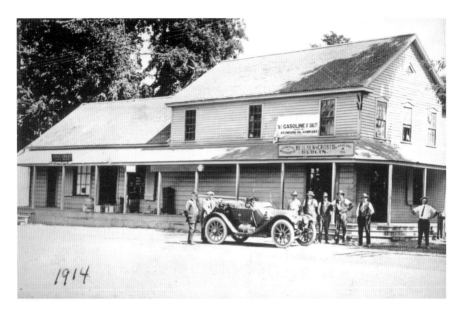

Dublin's general store was central to the community for decades. Best known as Green's Store, the building was operated and owned by many Dublin residents. *Dublin Heritage Park & Museums.*

shops often had small roadside cafés nearby. And one of these was located just west of the current Dublin/Pleasanton BART station parking structure. That café also had overnight lodging of the most basic kind: small bunkbeds for rent to truckers. Even by the austere standards of the Depression, they were probably cheap but not very comfortable.

The hotels and their associated restaurants were an important part of the community and catered to local farmers, ranchers and the cowboys who competed in the nearby annual Rowell Ranch rodeo. Marie and John Boero were longtime owners and operators of the only restaurant in Dublin: the Dublin Hotel. Sometimes the lodgings became part of local folklore. Rowell family history described a drunken brawl there between Elizabeth Rowell's husband, rodeo star Charles "Dogtown Slim" Leusch, and her father, rodeo organizer Harry Rowell. The fight took place in 1940 on the day of the birth of Elizabeth and Dogtown Slim's son.[123] The fight between the two very drunken men had something to do with who would have the greater influence on the baby's upbringing.

For the final time, the Dublin Hotel burned down in 1961. One of the several reincarnations of the Amador Hotel, it did not get rebuilt. At about that time, the lodging business started to fade away since there were fewer

Above: This truckers' bunkhouse was next to a gas station along Highway 50 in 1942 near what is now the Dublin/Pleasanton BART station parking structure. *Museum on Main, Pleasanton.*

Left: The Dublin Hotel, and the various restaurants in it over the years, stood on the southwest corner of Dublin Boulevard and Donlon Way. *Dublin Heritage Park & Museums.*

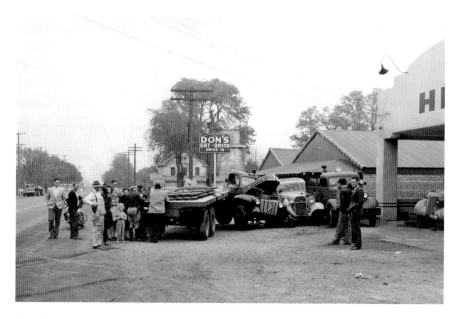

Don's Restaurant served the traveling public for many years. It was located on Highway 50 (now Dublin Boulevard) at what is today the Dublin Heritage Park. *Dublin Heritage Park & Museums.*

people needing motels or hotels. The related service they provided, meals, continued to be needed for the traveling public and residents. The Dublin Corral catered to Dublin and nearby residents until 2001. Dublin was without a hotel until 1968, when the Howard Johnson hotel chain built a 120-unit motel near the Interstate 580 Foothill/San Ramon Road intersection. The lodging changed hands several times before its current owner, Holiday Inn, took over. Later lodgings started to be constructed in the eastern part of the city but still along the Interstate 580 corridor. Today, several hotels in Dublin continue to cater to Interstate 580 and 680 travelers, just as the smaller hotels did for travelers along the routes in the 1860s.

SUPPLEMENTING THE ROADS: THE RAILROAD FINALLY ARRIVES

Dublin's eighteenth-century development never really took place because railroads bypassed the crossroads. While some sources suggest that Dublin Canyon was considered for the transcontinental railroad, the railroad

builders selected Niles Canyon. Pleasanton benefited from that decision and grew along with the increasing passenger and freight traffic that followed the Southern Pacific and Western Pacific Railroads. Various alternatives to bring a railroad to Dublin over the years were suggested, including a narrow-gauge railroad from Hayward to Dublin through the canyon. That never worked out. The San Ramon Branch line extended from San Ramon through Dublin's outskirts to Pleasanton around 1907, but the only freight stop was at the largely imaginary town of Dougherty. The stop was located at what is now the intersection of Dougherty Road and the Iron Horse Trail. From then through the 1970s, the railroad only marginally affected Dublin's development.

Part of Dublin's attraction as a residential community was its excellent location near highway and later interstates. As development grew dramatically throughout the San Francisco Bay Area, that attraction diminished as roads became ever more congested. A railroad, this time the San Francisco Bay Area Rapid Transit District (BART), was to be the new solution. A 1957 regional plan recommended a high-speed rail system to connect the cities and counties of the Bay Area. Between 1957 and 1962, BART developed the system's plans. Construction started in 1964, and the basic system opened on September 11, 1972. By that time, expansion plans included tracks to be added from San Leandro through Castro Valley to Dublin and then Livermore. The route followed Interstate 580 through Dublin Canyon, paralleling the centuries-old route originally made by Native Americans. Twenty-five years later, the Dublin/Pleasanton line opened on May 19, 1997.[124] Dublin finally had its passenger railroad. Appropriately, Dublin's first twentieth-century passenger station was built at an intersection near the old 1907 railroad right-of-way. The Dublin/Pleasanton station was an instant hit. Dublin's second station, West Dublin/Pleasanton, opened in February 2011.

Chapter 4

WE WERE STATIONED HERE

S hortly after December 7, 1941, the United States realized it was woefully unprepared to train and deploy personnel and resources into the far reaches of the Pacific Ocean and Asia. Both the army and the navy scrambled to find bases on the West Coast to support the needed war effort. Leveraging its existing bases in and around San Francisco, the Navy Bureau of Yards and Docks sought potential bases and construction sites throughout the Twelfth Naval District in Northern California.

About twenty-nine miles southeast of San Francisco, the navy found a good road and rail network, sparsely populated land and cheap real estate. The navy immediately set out to acquire large tracts of land near the tiny crossroads of Dublin and the small towns of Livermore and Pleasanton. It identified about 3,396 acres (5.3 square miles) just east of Dublin along Highway 50. The land included parts of Alameda and Contra Costa Counties. On October 29, 1942, a local appraiser valued the property at $497,446.[125] The area included all the land between Dougherty and Tassajara roads and extended from Highway 50 (currently Interstate 580) north far into Contra Costa County.

This land soon housed two large naval bases, a hospital and a navy jail with thousands of buildings and, ultimately, nearly 100,000 new part-time residents. After World War II, the U.S. military would find other valuable reasons to have U.S. armed forces personnel and their families live and work in Dublin.

Camp Parks (Naval Construction Battalion Rest and Recuperation Center)

Besides new bases, the navy needed new types of personnel. To build these bases, harbors and airfields, Rear Admiral Ben Moreell came up with a radical solution. He advocated enlisting men with construction skills and training them to fight rather than enlisting young men to learn to build and learn to fight. Naval construction battalions started forming in 1942. They included all the necessary skills, equipment and supplies to build anytime, anywhere. These sailors were later known as "the Seabees." By the end of the war, more than 325,000 men had served with the Seabees.[126]

The base outside Dublin was to allow returning construction battalions to refit after deployment in the Pacific theater of war. There the Seabees would receive rest, recuperation, replacements, new clothing and equipment. They would also learn new construction skills and techniques. A hospital would take care of wounds, injuries and illnesses. Then they would ship off again.

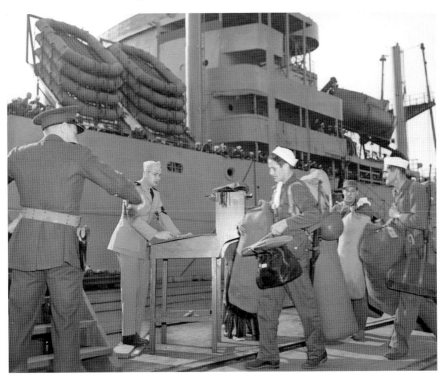

Seabees with all their gear check in as they board a transport to the Pacific theater of war during World War II. *Dublin Heritage Park & Museums.*

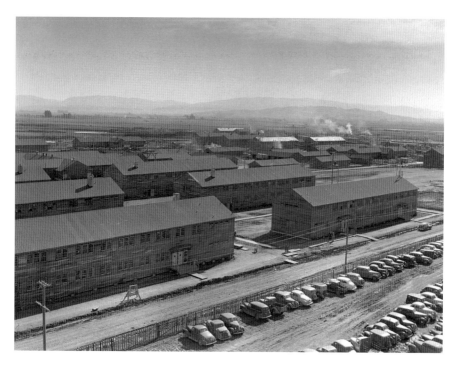

Construction workers parked their cars at the job site near Dougherty Road. These were new barracks at Camp Parks in 1942. *Dublin Heritage Park & Museums.*

Construction began on Camp Parks on October 15, 1942. Named after Rear Admiral Charles Wellman Parks, Civil Engineer Corps, who led the navy's Bureau of Yards and Docks in World War I, the navy opened the camp for operation on January 19, 1943. According to its administrative history, Camp Parks's primary function was the "housing, formation, and training of Construction Battalion units and drafts." In time, other major functions besides the recuperation of men and units following deployment and the redeployment back into service were added. The Sixtieth and Fifty-Sixth Naval Construction Battalions were the first two full battalions to move into Camp Parks. Initially, there were ten barracks areas designed to house one construction battalion each, five mess halls and bachelor officer quarters, a main administration building and several single-story wooden storage buildings. The base expanded even during construction and again in the spring of 1943. New buildings included cold storage, recreational buildings and training facilities. By September 1943, construction had begun for five more battalion areas. Quonset huts were used to provide additional storage and occupancy.

There were more than 110 wooden two-story barracks built at Camp Parks. They were only intended to last "for the duration" of the war. *Dublin Heritage Park & Museums.*

By the end of the war, the navy construction at Camp Parks included 110 wood barracks, 146 other wooden buildings, 697 Quonset hut barracks, 348 other Quonset huts and 61 steel buildings. Overall, there were more than 3.1 million square feet of constructed space by November 1, 1945. On average, Camp Parks trained more than 3,800 men each month. At its busiest, in April 1945, more than 20,000 men were on the base. During World War II, Camp Parks outfitted 109,120 personnel in more than three regiments, sixty battalions and sixty battalion detachments. About seventy-one separate Seabee battalions went through Camp Parks at some point between 1943 and 1945. The navy closed the camp in January 1946.

In modern terms, World War II Camp Parks occupied the land between Dougherty Road and Hacienda Drive. It also stretched between what is now Interstate 580 and several miles northward into Contra Costa County. The original camp was much larger than modern Parks Reserve Forces Training area.

Camp Shoemaker
(the U.S. Naval Receiving Barracks that Became the U.S. Naval Separation Center)

Camp Shoemaker was located just east of Camp Parks. Construction started as part of the original contract with McNeil Construction Company.

On May 15, 1943, it was commissioned as the Navy Personnel Distribution Center. Shortly thereafter, it was renamed the Naval Receiving Barracks. Throughout the early part of the war, it was also known as Camp Shoemaker. As stated in an orientation pamphlet, "Its purpose, simply stated, is to give men a place to sleep and a bite to eat while waiting transportation to a ship or an advanced base." Starting with 50 officers and 400 enlisted men on 689 acres, the Receiving Barracks "a few short weeks before had been a cow pasture." Within a year, the Receiving Barracks were taking in 2,223 men and transferring out to the war in the Pacific 2,495 sailors per day. A monthly turnover could be as many as 50,000 men. By the end of the war, it had become the last naval facility sailors saw as they waited for discharge papers and transportation home. Thousands and thousands of sailors went through Camp Shoemaker during the war.

On pay days, the disbursing officers were paying out about $1 million per month. At final operating capacity, the Receiving Barracks (also known as the station) had facilities for approximately thirty thousand transient personnel and three mess halls capable of serving ten thousand at each meal. The facilities included four theaters collectively seating six thousand, forty-four bowling lanes, forty pool tables, four swimming pools, a drill hall containing four basketball courts, ten tennis courts, one regulation baseball diamond, two football fields, nine softball diamonds and five indoor recreation buildings. Sports were a very important pastime, and the "Fleet City Bluejackets" fielded football, baseball and basketball teams. The navy closed the Separation Center in 1946.

Camp Shoemaker was not just a place but a temporary collection of thousands of real people who lived and anxiously awaited their futures. It included many thousands of stories of those who were lucky and those who were unlucky. Harry "Bob" Herring wanted to join up after Pearl Harbor, like millions of other young men. In 1944, he was surprised that he hadn't heard from his draft board, not knowing his boss at the Wyoming lumber mill had put him in for a deferment. Outraged, he quit his job that day and enlisted. He went through boot camp in Farragut, Idaho, spent time at Camp Shoemaker and was transferred to a radio school near

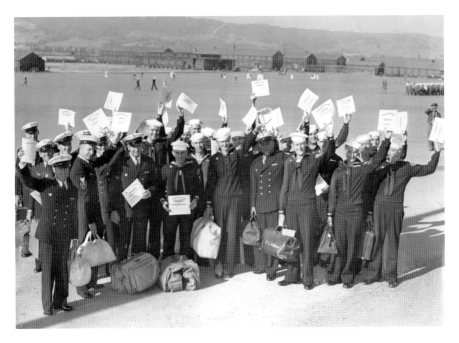

These Seabees wave their discharge papers as they get ready to leave Camp Parks in 1945. *Dublin Heritage Park & Museums.*

Pearl Harbor. While working there in the communications office, he met the woman he would marry. They returned to Encampment, Wyoming, after the war.[127] Another sailor arrived one day in 1944 just like tens of thousands of others. Instead of walking from the railroad unloading point like others, he decided to make it easy on himself by jumping onto a truck carrying the group's sea bags. The driver didn't know he was on top. The truck drove under a low overhang, and the sailor hit his head. His injuries were so bad he eventually died.[128]

In modern terms, Camp Shoemaker occupied the land between Hacienda Drive and Tassajara Creek. It also stretched between Interstate 580 and the Alameda County/Contra Costa County line.

SHOEMAKER NAVAL HOSPITAL

Shoemaker Naval Hospital was located just east of Camp Shoemaker. Construction started after Camp Parks was finished but while Camp

This was a typical bedside view at Shoemaker Naval Hospital. There were more than thirty-one wards caring for as many as three thousand patients at a time. *Dublin Heritage Park & Museums.*

Shoemaker was still under construction. The navy originally intended it to treat returning Seabees. But as the sheer scope of the local navy activities became obvious, the hospital became critical to the functioning of both camps and their intended function of staffing the fleet in the Pacific.

Commissioned on October 1, 1943, Shoemaker Naval Hospital was the second new naval hospital built on the West Coast that year and had one thousand beds in thirty-one wards when completed. Later construction in October 1944 increased the number to three thousand beds. The hospital was unlike all other navy hospitals built on the West Coast. It had a distinctive design with four radial groups of wards that looked somewhat like a giant *X* from the air. All the buildings were temporary wooden-frame construction. Between October 1943 and January 1946, the hospital admitted 45,960 patients, with as many as 3,029 patients there at one time. The patients included sailors and marines from Camp Shoemaker and other area bases. On V-J Day (Victory over Japan Day, September 2, 1945), it had 3,031 patients. The navy closed the hospital on June 30, 1946.

In modern terms, Shoemaker Naval Hospital occupied a large area of eastern Dublin, including most of what is now Emerald Glen Park. Its eastern boundary was Tassajara Road, and its western boundary was Tassajara Creek. Its southern boundary was along Interstate 580. Its northern boundary was near the Alameda County/Contra Costa County border.

FLEET CITY

Around 1944, the navy decided that it could improve its operational efficiencies by combining the separate bases under one commander. Local newspapers continued to mention Camp Parks and its usually newsworthy

16 JOSEPH GIEB, Half
41 JOHN BADACZEWSKI, Guard
6 QUENTIN KLENK, Tackle
27 ROCCO PIRRO, Center

36 PAUL PATTERSON, Half
30 LESTER GATEWOOD, Center
45 "UGGY" UGUCCIONI, End
24 HARRY HOPP, Full

12 FRANK KOSIKOWSKI, End
31 CHARLES MEHELICH, End
50 CHARLES RIFFLE, Guard
15 STEVE JUZWIK, Half

8 V. R. JANSANTE, End
34 EVAN VOGDS, Guard
42 DOYLE TACKETT, Full
18 BUDDY YOUNG, Half

12 **BLUEJACKETS**

A Fleet City Bluejackets football program shows that it was one of America's few integrated teams, with Buddy Young and Paul Patterson. *Author's collection.*

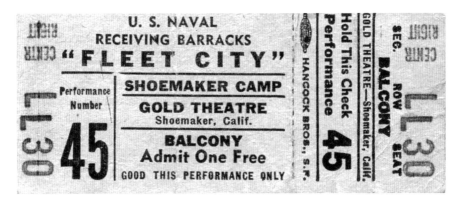

Camp Shoemaker had two theaters. According to notes on the ticket, Robert Armstrong, Chico Marx, Bonita Granville and Danny Kaye entertained the sailors that day. *Author's collection.*

Seabees in many articles. The navy started calling all three activities "Fleet City." The combined bases made up one of the largest naval training areas in the country.[129] On any given day in late 1944, there were usually more than ninety thousand sailors there.

With that many young men and women around, it was important to give them entertainment and exercise. There were several theaters at the three bases, each of which could hold hundreds of customers. Big-name entertainers played regularly for the sailors. Movie actors such as Chico Marx, Danny Kaye, Dennis Day and Bonita Granville appeared on stage. Even the nationally popular radio show *Duffy's Tavern* was staged live at Camp Shoemaker.

While each of the bases had intramural teams, they fielded individual camp teams and a consolidated all-camp team. Regular contests included softball, baseball, basketball, track and field and other sports. There were even women's teams, this at a time when women were just beginning to compete after some high school sports. The Camp Shoemaker sports teams became the Fleet City Bluejackets and started appearing on the sports pages throughout the San Francisco Bay Area in 1944 and 1945. In 1945, the Fleet City Bluejackets football team was ranked the number one service team in the country. As many as fifty thousand civilians and service personnel watched them beat the Marine Corps Air Station El Toro (California) Flyers at San Francisco's Kezar Stadium.[130] In another history-making development, the Bluejackets were an integrated team. Claude "Buddy" Young, inducted into the Professional Football Hall of Fame in 1968, played halfback in the 1945 season.[131] Paul Patterson played halfback as well.

KOMANDORSKI VILLAGE

Soon after Camp Parks, Camp Shoemaker and Shoemaker Naval Hospital were built, it became apparent that personnel at the base and, increasingly, their families needed a place to live. While some camp personnel could live in barracks, others who were longtime residents and had families needed more appropriate quarters. The local communities of Dublin, Pleasanton and Livermore could barely house their residents, as well as all the new civilian construction and service workers and families streaming to the region. Newspapers had many notices advertising for boarders in homes and garages. In one newspaper article, readers were warned about unscrupulous advertisers who offered to rent rooms for money in advance. It turned out that many of them did not even own the homes to which they sent people.

Komandorski Village was the solution to the navy's "dependent families" housing problem. Like similar naval housing developments throughout the San Francisco Bay Area and the country, it was named after a World War II battle. Located west of Dougherty Road and just south of what is now Amador Valley Boulevard, buildings at Komandorski Village were much the same as at Camp Parks and Camp Shoemaker. They included rough-cut wooden two-story barracks buildings and Quonset huts. The buildings were intended to be temporary war housing and must have been less than comfortable to many of their tenants.

After the war, the buildings were made available to civilian occupants, while most of Camp Parks and Camp Shoemaker buildings were sold at auction. By 1954, they became low-income housing administered by the City of Pleasanton. A small local grocery store provided food and other items. Through the 1950s and 1960s, families and individuals took advantage of the 150 housing units. However, the structures were not well maintained and became run-down. In June 1980, the Komandorski community center was destroyed in a fire.[132] By August 1982, the area was redeveloped, with new housing for fifty-three families and a new name, Arroyo Vista.[133] In late 1986, the recently formed Dublin Housing Authority took over management of the housing project. The area was showing signs of age, and the City of Dublin started looking at new proposals for fixing up the property. After many plan reviews, residents were moved out in 2008 in preparation for new construction. However, it wasn't until 2013 that the newly rechristened Emerald Vista opened. This time, the development was a mixed housing development with market rate and low-income housing.[134]

Throughout this period, Komandorski Village kept its informal name and appeared on U.S. Geological Service maps. The name still appears on many online maps, even though it has had many different neighborhood names.

Fleet City Recycle and Reuse

The naval bases were always intended to be temporary, to only last "for the duration" of the war. The U.S. Navy closed its World War II Seabee base at Camp Parks in early 1946. Remaining operations at Camp Shoemaker ended later that year.

Soon thereafter, the land and vacant buildings reverted to the War Assets Administration. The federal government recognized as early as 1944 that there would be a huge amount of excess property and material when the war ended. The War Assets Administration was formed to handle the disposition of surplus property in accordance with the War Property Act of 1944.[135] As part of this national effort, entire buildings at Camp Parks and Camp Shoemaker began to be auctioned off to the public. There were more than 1,500 buildings at the two camps. By 1947, almost all the Camp Parks and Shoemaker buildings were gone.

Comments from several local area residents and National Archive and Records Administration documents describe the widespread sales that drew buyers from around the San Francisco Bay Area. The usual arrangement was for members of the public to bid on buildings. Part of the arrangement was that the bid winners would disassemble the buildings and haul them offsite within about a month.

Carol Kolb Strom, who grew up in Dublin during and after the war, said that many local farmers bought buildings to reuse the wood, doors, windows and plumbing for other uses. She noted that her father bought so much cheap lumber that he was still using his supply decades later.

Those seeking cheap building supplies (and buildings) came from near and far. Many of the Quonset huts wound up as storage sheds, barns and even businesses all over the region as many sought to supply the postwar building boom. The wide-scale purchase of barracks, buildings and Quonset huts reflected a new situation in the San Francisco Bay Area. Tens of thousands who came to work in the war economy stayed in the San Francisco Bay Area because of the economic opportunities, climate and the comparatively more open social environment. Tens of thousands

who served in the armed forces in the Pacific theater of war decided to stay for the same reasons.

In one circumstance, the auction of surplus buildings resulted in the saving of an architectural landmark. Camp Parks's architecturally unique McGann Chapel was sold to a local church and disassembled. At its initial construction, Seabee architect Bruce Goff transformed two Quonset huts with steel beams, blue glass and finished lumber into a remarkable church. The chapel even had a water feature. He also custom-designed all the furnishings, including the lectern, pews, chairs and tables. Purchased in 1946, San Lorenzo Community Church congregants disassembled the building, transported the material and reconstructed the chapel in San Lorenzo. It had its first service on December 21, 1947. Navy chaplains participated in the opening ceremonies. The church still stands and is in use today.

In another case, the Camp Shoemaker Officer's recreation building became a clubhouse for a postwar residential and recreational development outside Tracy, California. The barracks-style building still exists decades later,

Architect Bruce Goff designed Camp Parks' McGann Chapel while he was a Seabee there. In 1947, San Lorenzo Community Church moved it to its current location. *Dublin Heritage Park & Museums.*

bringing recreational opportunities to families who were established after the war. And in the largest example of reuse, Camp Shoemaker's Disciplinary Barracks became Alameda County's new Santa Rita Jail, housing inmates from 1946 until 1989.

There may be even more examples of Fleet City's recycle and reuse. Some stories say that a local Livermore congregation bought and moved a Camp Shoemaker church. That church was said to be somewhere along East Avenue.

PARKS AIR FORCE BASE

Camp Parks and Camp Shoemaker land sat unused after the disposal of most of the buildings. Shoemaker Hospital sat unused as the federal government negotiated with the County of Alameda for a possible land and building transfer. At that time, it seemed unlikely that the area needed a one-thousand-bed hospital since the total population of Livermore, Pleasanton and Dublin probably was not even seven thousand.

International events were soon to affect the Dublin area again. With the North Korean invasion of South Korea in June 1950, the U.S. Air Force needed to rapidly expand its recruitment and training. It chose the former Camp Parks land as a site for a new basic training center. The navy began the land transfer process in early 1951. By June 1951, construction had begun on Parks Air Force Base.

The air force had to completely construct a new base on what was 3,636 acres of mostly barren ground. Base personnel were initially housed in temporary facilities and ate from a field mess. The first group of airmen arrived at Parks in the summer of 1951. Large-scale training began in March 1952. In August 1951, the 3,275th Air Indoctrination Wing started operations at the newly commissioned Parks Air Force Base.

Founded to provide basic training to the influx of new airmen for the air force's Korean War response, the facilities were not quite as extensive as the navy's Camp Parks. And in what was unusual for an air force base, there was no paved runway. Over the next few years, thousands of young men received basic training. Adjacent to the base, the air force took over the former World War II vintage navy hospital buildings and renovated them into the regional air force hospital. Eventually, other units and missions came to the base.

This two-story building housed the headquarters for Parks Air Force Base. Located near the current Camp Parks chapel, it was demolished sometime after 1970. *Dublin Heritage Park & Museums.*

By January 1958, the air force had decided that it no longer needed Parks Air Force Base. At about the same time, other similar air bases were closed around the country. Facilities at Lackland Air Force base could handle all the service's recruitment needs. Some personnel processing continued at Parks until July 1959, when the air force closed the base and transferred the facility to the army.

THE COLD WAR COMES TO DUBLIN

At the height of the Cold War, Dublin became a quiet test bed for some unlikely experiments. Among the tenants on the property of the old Parks Air Force Base was the U.S. Naval Radiological Defense Laboratory. Its mission included testing the health effects of radiation and defenses against

radiation. Its headquarters was in San Francisco at Hunter's Point Naval Shipyard. The Laboratory started obtaining land in 1959 at Camp Parks to conduct tests on prototype bomb shelters and radiation testing on animals.

One of the shortcomings that the United States had during the Cold War was that there were no official standards for building fallout shelters. Many shelters throughout the country were hastily organized spaces underneath buildings that might, or might not, protect people from the radiation effects of fallout after a nuclear weapon explosion. No one knew which designs were best to house men, women and children while they waited for the fallout's radiation to diminish. No one knew how people would react to the crowded conditions within a fallout shelter or how long (days, weeks or months) they could live together before discipline or hygiene would break down.

For two weeks in December 1959, the Naval Radiological Defense Laboratory conducted a test to find out how one hundred men in an experimental buried bunker at Camp Parks would react to living in a fallout shelter. Ninety-two of them were volunteers from Santa Rita Jail. They were screened to weed out medical and behavioral issues from an original four hundred volunteers. The "shelterers" were monitored by Alameda County deputy sheriffs and physicians, as well as a trained shelter commander and assistant. The men were aged between seventeen and sixty-two years old and lived in the twenty-five-foot-wide, forty-eight-foot-long "buried flexible-arch" structure. They slept on double rows of canvas bunks stacked four high. Each night they were entertained with recorded music, films and "talks about atomic weapons and fallout." There were four different experimental diets, one of which included a Planters Jumbo Block Peanut bar and a vitamin capsule that "met nutritional requirements for $.31 per person per day but gave some inmates diarrhea." Another diet consisted of C-rations, which cost slightly more per person per day but were the preferred choice "though they caused constipation."[136] The test concluded with no serious issues reported, and the inmates had their sentences reduced for participating. It was said that everyone settled down after the first forty-eight to seventy-two hours. The armed deputy sheriffs standing guard outside probably helped.

Since the Naval Radiological Defense Laboratory concluded that it was possible for incarcerated people under armed guard to live for extended times in close quarters, it decided to try a shorter test on another set of people: its staffs' families. In November 1960, the experimental shelter housed ninety-nine men, women and children for forty-eight hours over a weekend. The group included families and single persons ranging in ages

from three months to sixty-eight years old. Once again, all aspects of the group were monitored. The report concluded, among other things, that "children of all ages appeared to adapt well to shelter conditions, but the importance of careful preparation, organization, and control of activities was demonstrated."[137] There was even a poem, of sorts, submitted by one of the "shelterers" that appeared in the final report:

"The Shelter"
(Sort of a Limerick)

It's a den of noise
Filled with fidgety boys
Our home beneath the firmament
And I'm glad it's a phase
Just lasting two days
Rather than something that's permanent.[138]

Santa Rita Jail inmates come out of a fallout shelter after a two-week fallout shelter experiment in December 1959. *Alameda County Sheriff's Office Archive.*

The underground shelter may have been used for subsequent experiments, but none of them used as many people. It was filled in and covered over by the army in the 1990s.

Later in the 1960s, the laboratory conducted radiation testing on animals. The purpose of the testing was to evaluate the effect of various doses of radiation on animals' health. Four movable sources on flat cars moved along a narrow-gauge railroad track in an isolated test area surrounded by barbed wire fences. Over the years, sheep, burros, goats, pigs and dogs were exposed to highly radioactive sources, and their health and exposures were closely evaluated.[139] Many of the animals died and were buried in a large pit near the Camp Parks property. There is no evidence that there was ever any radiation testing on people at the laboratory's activities at Camp Parks.[140]

The Naval Radiological Defense Laboratory stopped operations in 1969. Testing operations at Camp Parks continued at least through 1972 under a U.S. government contract with Stanford Research Institute. It is unknown when testing operations finally stopped.

THE PARKS JOB CORPS CENTER: THE GREAT SOCIETY COMES TO DUBLIN

In 1964, President Lyndon B. Johnson promoted a national effort called the "War on Poverty." A key aspect of the effort was to expand economic and social opportunities for Americans, especially minorities and the poor. The Economic Opportunity Act of 1964 established the Job Corps. Its mission was to attract eligible young people, teach them the skills needed to become employable and independent and place them in meaningful jobs or set them up to attain further education.[141] Patterned after the successful Depression-era Civilian Conservation Corps, the training would be a residential program with dorms, meals, education and training all provided for free to eligible young men aged sixteen to twenty-four. The Federal Office of Economic Opportunity chose unused parts of the former Parks Air Force Base to be the San Francisco Bay Area location.

In late April 1965, the first thirty-three "Corpsmen," as they were called, arrived. A fair number were reported by local newspapers as being just a bit overwhelmed about their first trips away from their families and friends and sudden arrival in the run-down, nearly abandoned and windswept former air force base. By August, there were 845 residents taking remedial reading

Two trainees work on a pickup truck at the Parks Job Corps Center. *Dublin Heritage Park & Museums.*

and writing, automotive, electronics, culinary arts, office machine repair, office occupations and maintenance service courses. The Job Corps staff of teachers, shop foremen, dorm monitors and administrators numbered several hundred. The center itself eventually included 187 buildings, including 2.1 million square feet of dorms, shops, mess halls, gyms and training areas.

Even before the center's opening, local Dublin, Pleasanton and Livermore newspapers wrote articles describing the dramatic changes people thought might occur. In retrospect, it seems there was a bit of racism about "all those inner-city kids and delinquents" being "dumped" in the area. Many, but not all, of the "Corpsman" were non-white and from poor families. Some had previous run-ins with law enforcement in their hometowns. And there were some problems, including fires (accidental and intentional), at the site and a "riot." Staff at the Job Corps site said they handled the incident themselves and later called it something like a pillow fight gone wrong. Some of the newspapers described it as a full-fledged out-of-control fight. The Santa Rita Alameda County sheriff substation nearby responded to a teacher's telephone call with five carloads of deputies. The site denied them entry and said it was under control. A *San Luis Obispo Telegram-Tribune* reporter

In 1969, recent Olympic gold medal winner George Foreman presented President Lyndon Baines Johnson a plaque for his support of the Job Corps. *Dublin Heritage Park & Museums.*

visited Pleasanton to gain some insight into what his city might expect from the opening of a center nearby. He noted that the center seemed to work closely and well with the city officials in Pleasanton. He reported that "nine miscreants of 1,200" did not seem to be too much to worry about.[142]

The experiment in expanding economic and social opportunities for minorities and the poor at Parks Job Corps Center ended in 1969. Richard Nixon's administration and Congress cut back Job Corps dramatically. According to the *Livermore Herald & News*, the last Corpsman left in June 1969 and the last staff person in early July. The article noted that more than sixteen thousand had lived and learned there during its existence.

Probably the most memorable aspect of Parks Job Corps history is the fact that George Foreman, Olympic (1968) and heavyweight (1973) boxing champion, credited it with his success. Foreman came there as a Corpsman and later wound up working there. There are several versions of Foreman's early story, but the common theme is that the Job Corps taught him discipline and introduced him to boxing and excellent trainers. This is said to have helped him become a champion and, at least for a time, a resident of the San Francisco Bay Area.

Camp Parks and Parks Reserve Forces Training Area: The Army Arrives

It wasn't very long before the U.S. government found a new use for the former Parks Air Force Base. The U.S. Sixth Army, with its headquarters at the San Francisco Presidio, was looking for outlying facilities to take care of Army Reserve components. The Army Reserve consists of units and troops who have ongoing service commitments after their active duty ends. They had to keep current on their skills and training. With its large open spaces, firing ranges, ample barracks and office spaces and close location to the San Francisco Bay Area, Camp Parks was the perfect place for reserve training.

From 1959 to 1973, Camp Parks went through a period of readjustments as missions were sought, given, changed and modified. For a time, the camp was in standby status under the jurisdiction of the Sixth Army. By 1964, the Sixth Army had declared the entire installation excess, but the Department of the Army directed that it keep 1,600 acres for National Guard and navy use. In the same period, property was transferred to the County of Alameda and used for a variety of activities, one of which was for the Job Corps Training Center. By 1973, the U.S. Army had determined that Camp Parks was needed as a mobilization and training center for Reserve Components in the event of war or natural disaster. In 1980, the army officially designated Camp Parks as a semi-active installation, renamed it Parks Reserve Forces Training Area, and declared it a sub-installation of the Presidio of San Francisco. By 1992, Parks had become a sub-installation of Fort Lewis, the first of several realignments. Today, it is part of the U.S. Army Installation Management Command, Central Region. From 1992 through 2000, the Army Reserve continued to find new and expanded uses for Camp Parks and the mostly empty land on it.

WE WERE INCARCERATED HERE

N o one likes to admit they have a jail or a prison in their town. Dublin has the dubious distinction of growing up around facilities built to incarcerate people convicted of crimes or waiting to be tried for crimes. As far back as 1944, Dublin started housing prisoners. First there were U.S. Navy and Marine Corps personnel accused of violating the Articles of War, the U.S. military's criminal code. After the war, Alameda County sheriff Howard P. Gleason thought that the old brig could be made into a model county jail. While time and events proved him only partially correct, Dublin slowly grew around the original Santa Rita Jail and subsequently housed the second, larger Santa Rita jail. And if that wasn't enough, the U.S. government found a home for its "Club Fed" in the brown hills of Dublin.

THE FIRST JAIL: U.S. NAVAL DISCIPLINARY BARRACKS, SHOEMAKER, CALIFORNIA

The United States Naval Disciplinary Barracks, Shoemaker, California was commissioned on 9 November 1944....Prisoners who have been received for confinement at this activity are of two types: those who will return to duty automatically on completion of sentences, and those, either probation or non-probation violators, who will be discharged with bad conduct or dishonorable discharges.[143]

During World War II (1941–45), the U.S. Navy built three bases in what would later become Dublin, California. Whenever there are about seventy thousand men (and women) living in one area, there is (usually) a need for a facility to take care of those who violate laws, rules and regulations. The Naval Disciplinary Barracks, Shoemaker, served that function for the navy.

Located near what is now Toyota Drive, the Disciplinary Barracks included high-security cellblocks, low-security barracks, exercise yards, office and work buildings, sports facilities, cafeterias, an auditorium, a chapel and other structures. It handled about 1,200 prisoners. It included navy sailors, marines and Coast Guard sailors who had violated a range of rules and regulations from relatively minor infractions to more serious crimes such as desertion. Most prisoners eventually returned to service, while others were "discharged with bad conduct or dishonorable discharges."

Despite navy comments to the public and writing in its own history, the U.S. Navy Disciplinary Barracks housed some men who actively sought to get out any way they could. The barracks were generally designed to keep sailors and marines in who intended to serve their time and return to their service. It was not built as an "escape proof" maximum-security facility. In fact, it was built as a temporary facility expected to last only through the end of the war. Some men, who were in for serious crimes, especially after World War II ended, did not intend to wait. The *Modesto Bee and News-Herald*'s September 19, 1945 article "Six Navy Prisoners Are Caught After Escape" noted: "CAMP SHOEMAKER….Six navy prisoners serving sentences on hard labor today…escaped…and surrendered themselves when cornered by marine guards an hour later."

Besides navy and marine prisoners, the Disciplinary Barracks also housed about nine hundred German prisoners of war. The prisoner of war camp opened in early July 1945, with the first prisoners arriving later that month. Technically, they were waiting to be returned to Germany since the war in Europe had ended in May. They served at Camp Parks, Camp Shoemaker and the hospital in kitchens, laundries and in public works, transportation and housekeeping activities. The prisoner of war camp closed in 1946.

After it closed, the facilities lay unused and essentially abandoned. In August 1946, Alameda County sheriff Howard P. Gleason asked the navy to transfer the buildings and property. Sheriff Gleason planned to take his earlier success with prisoner rehabilitation through agricultural work and move it to a new, larger site. The navy accepted the proposal. Sheriff Gleason

and his staff inspected the former disciplinary barracks and made plans for improvements. On January 11, 1947, the new Santa Rita Rehabilitation Center opened.

THE SECOND JAIL: THE ORIGINAL SANTA RITA JAIL

[In 1936, Alameda County sheriff] *Driver was in charge of, and I believe he started, the farm concept for keeping minimum security prisoners, he and Earl Warren, who was then District Attorney.*
—former deputy sheriff Robert M. Leonard,
Alameda County Sheriff's Archive interview, March 1996

The approximately 3,300-acre area of Santa Rita looked quite different to the drivers speeding past on Highway 50 outside than it did for the prisoners inside. In fact, few outsiders ever saw the interior of Greystone, the high-security buildings. Those on the inside knew quite intimately what the inside looked like.

Roughly speaking, the original Santa Rita Jail was located between Hacienda Drive and Tassajara Creek. It stretched along Highway 50, which is now Interstate 580, to the Alameda/Contra Costa boundary. Almost all the buildings were near the intersection of Tassajara Creek and Interstate 580. This was where the eastern part of Hacienda Crossings is now. Support areas, such as the hog farm and field crops, were located between what is now Hacienda Drive and Tassajara Creek.

Within the jail complex, there were several areas. Greystone consisted of one building with two separate sides: East and West Greystone. Greystone was the maximum-security area. It was on the southwestern side of the complex. Little Greystone included the medium-security area and consisted of repurposed wooden barracks. It was located near the center of the complex. The women's prison was near the northwestern corner of the complex. The main entrance faced what is now Interstate 580 near Tassajara Creek. Before it became a freeway, cars would come from Pleasanton on Old Santa Rita Road, cross the highway and enter the complex.

Inside Greystone, the maximum-security buildings, about 273 men lived in twelve- by eight-foot cells. Each had double bunks, a sink and a toilet. The ceiling consisted of a heavy wire mesh, and guards walked above looking down into the cells as necessary.

Greystone was the maximum-security building at the Camp Shoemaker Naval Disciplinary Barracks. The same name was used at the original Alameda County Santa Rita Jail. *Alameda County Sheriff's Office Archive*.

Little Greystone was the medium-security area and housed prisoners in barracks-style buildings. Female prisoners had their own barracks-style area, including a sewing room. Other facilities at the jail included the mess halls, kitchen, bakery, auditorium, chapel, library, boiler house, laundry, clinic, dental offices, booking rooms, visiting rooms, firehouse, deputies' buildings, other support buildings and guard towers.

One of the unique aspects of the original Santa Rita Jail was that it was designed to be self-sufficient, at least in terms of food. Each day, deputy sheriffs would lead prisoner details out to the fields and hog and cattle farms that lay all around the jail. Crops included hay for hogs and cattle, as well as fruits and vegetables. Prisoners were provided work wear, straw hats and instruction in planting, harvesting and working farm equipment.

A prevailing idea in correctional philosophy at the time was that agricultural work would have a beneficial effect on prisoners. Honor farms were opened in several counties in California. Alameda County's first farm was created in 1936 and located near 150th Avenue in San Leandro.

Unknown parties placed this sign in the median of Interstate 580 to protest the numerous escapes from the original Alameda County Santa Rita jail. *Alameda County Sheriff's Office Archive.*

As former deputy sheriff Robert Leonard related, "At the Prison Farm, the prisoners all worked. There were no employees to take care of their needs like cooks or janitors.... Separated into work groups one group would go every day and work at...Fairmont hospital....Another crew ran the chicken farm, another, the hog ranch, the dairy ranch, plus they worked in the quarry."

At Santa Rita in 1947, the same activities took place, although on a larger scale. Deputies acted as job foremen and guards. Sometimes the guards also acted as machinery operators, and sometimes the prisoners drove the farm equipment. Only those working off minor offenses worked in the farm areas. Those in custody for more serious offenses were housed in Greystone.

When the County of Alameda took over after the war, the intent was to use Santa Rita to handle those men and women who were convicted of lesser crimes and who would appreciate the advantage of working in the county farm rather than being in the cramped and restrictive confines of the Sixth Street jail in Oakland. This worked for years. But as Alameda County grew, the scope and magnitude of crime in the county changed. The situation within the jail changed, and Santa Rita began to take in more and more prisoners, many of whom were convicted of very serious crimes. Despite upkeep and constant deputy sheriffs' efforts, the mainly wooden and temporary buildings and fences were inadequate and could not stop increasingly frequent and successful escape events. With just one fence between prisoners and Interstate 580, it was not uncommon for escapees to try their luck crossing the busy highway. In September 1981, an unofficial and embarrassing bright-yellow warning sign appeared in the Highway 50 median near the Hopyard and Tassajara roads intersection: "Warning Escapee Xing." As the *San Francisco Sunday Examiner & Chronicle* reported in November 1983, "Escapes are frequent and averaged better than one a week at their peak last year."[144]

Through the early 1980s, the escapee and overcrowding problem was reaching crisis proportions. In 1983, California superior judge Richard A. Bancroft ordered that the jail be replaced or shut down by 1986. The original Santa Rita Jail closed in September 1989.

The Third Jail: The New Santa Rita Jail

In 1982, the county started a design and development project for a new facility in Dublin, to be located about one mile northwest of the old jail. The new facility cost about $172 million and could hold about four thousand inmates. Times, circumstances and correctional philosophies had changed since the first jail opened in 1947. There would no longer be rehabilitation via agricultural work. The new jail included a then state-of-the-art robotic system that delivered laundry, supplies and food to various areas in the complex. The desire to reduce the jail's annual operating costs to the public remained, as the new complex eventually included solar panels and windmills. The earlier commitment to adequate care and rehabilitation opportunities continued with on-site medical, mental health, education and vocational training.[145]

The Other Jails: Club Fed and the Federal Correctional Institution Dublin

Dublin seemed to be the place to construct correctional facilities in the 1970s. With abundant government open land east of Dougherty Road, the United States Bureau of Prisons opened the Federal Youth Correctional Center (Pleasanton) in July 1974. It held about 250 young male and female offenders managed by a staff of 137. The 55 to 60 female offenders lived in separate quarters but ate and attended activities in coed areas. The center was designed as a low-security facility with the intention of providing education and vocational opportunities to young adults to help prevent them from becoming repeat offenders. That function changed in 1976, when it became an adult women's correctional facility. From 1979 through 1990, it was a men's and women's facility. By 1990, the U.S. Marshals Service had constructed a Federal Detention Center nearby. It was designed to handle federal suspects for pretrial holding and post-conviction, pre-sentence offenders. By March 1990, there were 712 incarcerated there and 285 staff working there. In 1993, the name was changed to Federal Correctional Institution Dublin. Another mission change occurred in 1995, when it started housing only female offenders again.[146] Since some of the facilities housed low-risk or white-collar offenders and had no high-security fences or aspects,

their spartan conditions still earned the term "Club Fed" by journalists seeking good copy.

Throughout this time, the federal facilities housed some famous, or notorious, residents and served as the location for one dramatic escape. Patty Hearst served time there. She was convicted in 1976 for taking part in a 1974 bank robbery. She was released in 1979 under commutation by President Jimmy Carter. Michael Milken, the junk bond financier convicted of illegal securities trading, was there from 1991 through 1993. Two former Los Angeles Police Department officers served time there from 1993 through 1996. They were convicted in 1993 of federal civil rights violations related to the 1992 Rodney King assault. Sara Jane Moore, convicted of attempting to shoot President Gerald Ford, was there from 1979 through 2007. In November 1986, an escaped prisoner (Ronald McIntosh) landed a helicopter in the exercise year and picked up another prisoner, Samantha Lopez. They escaped but were captured by the Federal Bureau of Investigation ten days later.

Chapter 6

WE MADE A CITY HERE

Much of Dublin's history has to do with creating community. The first efforts to create a community grew out of just making a living, but that led to establishing a school and religious centers and then social organizations. Each incoming group of residents followed similar paths. The fact that Dublin couldn't even decide on a name for itself had as much to do with individuals' and small groups' competing visions of "community" as with important economic events, like the railroads choosing to go through Pleasanton and Niles Canyon. Dublin didn't become a city around the times Livermore (1876), Pleasanton (1894) or Hayward (1876) incorporated.

Dublin was a community before it became a city. That community changed over time as people came and went, businesses strived and failed and the community's ethnic composition changed time after time. The changing community included churches, athletic clubs, social organizations, sports clubs and even a library. There is a time when residents realize that merely living together might not be enough. At that point, they must decide whether they want to take the extra effort to become politically active and create the legal entity that is a city. The people in Dublin chose to do that. This chapter describes a few of these sometimes unique, sometimes common situations that made Dublin grow over the years and decide to become one of the newest cities in California.

DUBLIN AND ITS LIBRARIES

In 1914, the library came to Dublin. For many years before that, the only somewhat large collection of books in Dublin could be found at Murray School. In May 1914, the County of Alameda opened a small branch library in the back room of the Green Store. It was a perfect location for the small community. People could come to the crossroads on an errand to pick up supplies and take the time to look through the small collection of books. It operated there successfully until June 1948.

After 1948, Dublin received services from the Alameda County bookmobile. The demand for better services surfaced again when families started moving into the Volk McLain development in 1960. Sometime soon after families started moving in, residents began to clamor for a local library. For a time, the need was met when Volk McLain let residents use the garage of one of the model homes as a makeshift library. The books were all donated by the nearby residents, and they provided volunteer part-time librarians. The bookmobile still showed up from time to time to serve the community. As the schools were built, each eventually had its own libraries to serve the students. Meanwhile, the community pressed for more local services from the Alameda County Library.

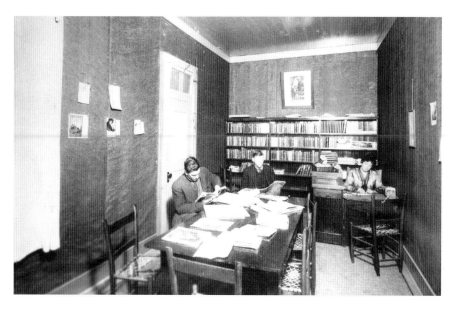

The Dublin Library reading room in the Green's Store circa 1914. The door opened onto the porch facing the Lincoln Highway (now Dublin Boulevard). *Dublin Heritage Park & Museums.*

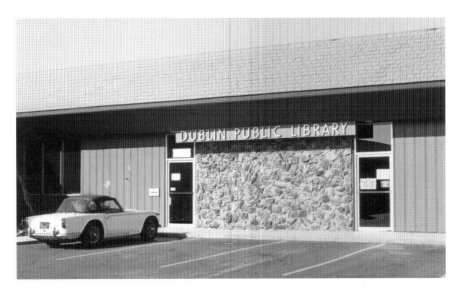

The Alameda County Library, Dublin branch, was located from 1970 to 1979 at 6930 Village Parkway. *Dublin Heritage Park & Museums*.

In April 1966, the demands were met when a portable library opened next to Dublin Elementary on Vomac Road. The trailer provided services while the community continued to grow dramatically. By 1969, the County of Alameda had secured a lease for a library in a building. Located in one of the new strip malls on Village Parkway, the library opened in February 1970. The location indicated how the center of the developing San Ramon Village was shifting to the south. The Vomac Road trailer closed by March.

Again, the existing public library had a difficult time keeping up with the swelling demand. Plans started to be made for a purpose-built library. By 1979, the plans had become reality when a new, bigger Alameda County Dublin Branch Library opened in March on Village Parkway. A large, well-lit and modern library had dedicated space for a large children's section and much more room for many more books and magazines. The library even had public meeting space.

By the beginning of the twenty-first century, the 1979 library building was insufficient for the growth that occurred. In part to reflect the new needs and a new pride in the newly incorporated city of Dublin, plans began for a new, larger library in the dedicated Civic Center complex on Dublin Boulevard. In April 2003, the latest library was built by the City of Dublin in a partnership with the Alameda County Library. Rather than starting an

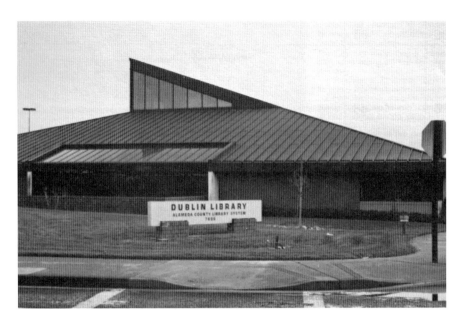

The Alameda County Dublin branch library on Amador Valley Boulevard. The first purpose-built library, it met the needs of the growing community for a number of years. *Dublin Heritage Park & Museums.*

independent city library, Dublin's city council decided to contract with the County of Alameda for library services. The city paid for and constructed the building and arranged a joint agreement for using and operating the library and the building. Dublin designed the building to complement the other Civic Center structures. In the agreement, Dublin paid for building upkeep and agreed to pay for part of the operational costs in cooperation with the county. The old Village Parkway library site was eventually used to build senior housing and the Dublin Senior Center.

The Dublin library continues to be a central part of the community. It offers many services and attracts one of the largest customer usage rates in the Alameda County library system. And as an added bonus, there is a time capsule buried near the entrance.

THE STRUGGLE FOR INCORPORATION, 1960s–1982

For many years, you could say that Dublin had a chip on its shoulder. There was resentment to being called "Scrubland," "Grubland" or "Renter Town."

Real and imagined slights came from officials and residents of Pleasanton and Livermore, as well as Danville and Alamo. Students told stories of Dublin High School being referred to as "Ghetto." Some 1960s residents even said Dublin had an image as the "blue collar" town in the valleys. It was thought of as the place you went to shop or get things repaired. At a time when diversity did not have the positive associations it does now, Dublin was known as a more mixed community than others nearby. Through the tremendous growth of the 1960s and 1970s, roads, streets, parks, schools, services and the general "look and feel" of Dublin had a low-end vibe. This did not sit well with many in the community. Adding to this dissatisfaction was a growing feeling that all the retail tax revenue was going to other parts of Alameda County. Many residents thought that the answer to the problem would be solved only if the community could control its destiny. This started the movement for city incorporation.

The early efforts to take control of the community started soon after the Volk McLain development brought many new people to Dublin. Many of the families came with young, school-age children. Parents rapidly joined the individual school parent-teacher associations. Starting in the 1960s, they also actively participated in the Murray School District Board meetings. After 1969, Dublin High School parents could participate in meetings of the Amador Valley Joint Union High School District to discuss, debate and comment on the activities and operations of their new school.

Throughout the 1960s and 1970s, the only other locally elected political authority was the Valley Community Services District. It was responsible for water, sewer, recreation, parks, fire and other services. Residents appeared before the board to comment, complain or just vent on many issues, some far beyond the scope of the district's responsibilities.

Service clubs such as the Lions, Rotary and Women's Club soon had many members and a strong commitment to the community. Other groups, such as the Exchange Club, filled a need for entertainment and engagement. These commitments included fostering the Dublin Pioneer Days and festivals and parades. The most popular of the festivals were the St. Patrick's Day celebrations. Real and imagined connections between Ireland and San Ramon Village/Dublin resulted in tremendous appreciation and participation for the annual parade. Of all the early community events, the St. Patrick's Day parade and festivities are the longest running and most popular Dublin events still taking place. With annual attendances of more than seventy thousand people, it is an incredible legacy from Dublin's twentieth-century community resurgence.

Ever since the county's organization in 1853, almost all governmental issues, including street and road issues, business licenses and property zoning, were all under the authority of the board of supervisors and county departments. Starting in the 1960s, more and more businesses were moving to Dublin, yet there wasn't any corresponding improvement in roads and streets. Decisions such as the federal government's disposal of old Parks Air Force Base land and the opening of the Parks Job Corps Center caused some residents concern and contributed to a feeling of little or no control. Newspaper articles commented often on how business owners and residents felt that county officials, far away in Oakland, were not paying adequate attention to the community's needs. At the same time, developing problems at the increasingly decrepit original Santa Rita Jail added to the local woes. It also seemed to Dubliners that the residents of Pleasanton and Livermore had the more convenient, and potentially more responsive, recourse through their city officials. There were also feelings that the Livermore and especially Pleasanton residents and officials were actively trying to keep Dublin from growing or gaining any independence. These feelings applied to county officials and their actions as well.

In 1966, Dublin community organizers started an effort to incorporate. They presented a petition to the Alameda County organization responsible for city planning, the Local Area Formation Commission (LAFCO). Created throughout California by the state legislature in 1963, LAFCOs were intended to "approve or disapprove with or without amendment, wholly, partially or conditionally" proposals concerning the formation of cities and special districts, as well as other changes of jurisdiction or organization of local government agencies. LAFCOs are required by legislation to consider factors such as the conformity between city and county plans; current levels and need for future services to the area; and the social, physical and economic effects that agency boundary changes present to the community.[147] Inherent in its charter and formation was a predisposition against the creation of new cities and special service districts. In fact, the Volk McLain development in Dublin was an example of just what was happening throughout California. This was the very situation many state and local government officials and voters thought needed to be controlled. LAFCO denied the petition.

In 1967, LAFCO permitted the community organizers to refile a petition for annexation of Dublin into the existing city, Pleasanton. While Pleasanton voters approved that idea (951 to 762), Dublin voters rejected the idea by a more than 3.7:1 margin (1,736 to 468).[148] For most voting Dubliners, it seems that no city was better than being in a city with Pleasanton.

Efforts continued at a subdued level until 1979. Organizers decided to approach incorporation from a different point of view. Rather than trying to incorporate on its own, Dublin would try to consolidate with the unincorporated community of San Ramon, just north in Contra Costa County. Realizing that it would take an act of the state legislature to allow one city to exist in two counties, proponents approached State Assemblyman Floyd Mori (D-Pleasanton). Assemblyman Mori requested a local referendum in Dublin and San Ramon to prove that the concept had widespread support. The November 6, 1979 referendum passed in Dublin (1,252 to 724) but failed overall by 228 votes (2,222 to 2,450).

The year 1979 was also the first for an extraordinary new state funding situation. In June 1978, California voters passed Proposition 13, which resulted in dramatically lower revenues for state and local governments. This directly affected the ability of the Valley Community Services District to pay for sewer, water, recreation and fire services to the Dublin and San Ramon areas. Incorporation activists used this argument to suggest that Dublin would not get any increased services to deal with the rapidly expanding community. It also helped that local revenues associated with the large sales tax could fund the new city government and services without adding to residents' tax burden. In fact, pro-incorporation arguments suggested that being a city might lower residents' tax burden. The Alameda County Board of Supervisors commissioned a study to evaluate the fiscal feasibility of Dublin's incorporation or, alternatively, annexation to Pleasanton. The board received the results in July 1980. The study found the following: "Fiscally, both incorporation of Dublin and its annexation to Pleasanton are highly feasible. With either alternative, city revenues will clearly exceed city costs, due to the unusual amount of sales tax collected in Dublin."[149]

The board of supervisors adopted a revised, final resolution applying for Dublin's incorporation in April 1981. Following a July 23, 1981 public hearing on the matter, the board called for an election.

The decision on whether to incorporate went before the voters on November 3, 1981. The ballot included two measures and eight candidates for a five-member city council. Measure A asked if the City of Dublin should be created, and Measure B asked if city council members should be elected by district or at large. At the end of the voting, Dublin was the newest city in California, winning by a large margin (2,126 in favor, 640 against), and its councilmembers would be elected at large. The first city council included Paul Moffatt, Peter Hegarty, Dave Burton, Linda Jeffery and Pete Snyder. The new city council elected Pete Snyder to be the first mayor.

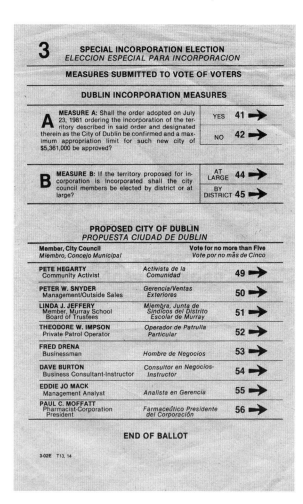

3 SPECIAL INCORPORATION ELECTION
ELECCION ESPECIAL PARA INCORPORACION

MEASURES SUBMITTED TO VOTE OF VOTERS

DUBLIN INCORPORATION MEASURES

A MEASURE A: Shall the order adopted on July 23, 1981 ordering the incorporation of the territory described in said order and designated therein as the City of Dublin be confirmed and a maximum appropriation limit for such new city of $5,361,000 be approved?

YES 41 ➡
NO 42 ➡

B MEASURE B: If the territory proposed for incorporation is incorporated shall the city council members be elected by district or at large?

AT LARGE 44 ➡
BY DISTRICT 45 ➡

PROPOSED CITY OF DUBLIN
PROPUESTA CIUDAD DE DUBLIN

Member, City Council *Miembro, Concejo Municipal*		Vote for no more than Five *Vote por no más de Cinco*
PETE HEGARTY Community Activist	*Activista de la Comunidad*	49 ➡
PETER W. SNYDER Management/Outside Sales	*Gerencia/Ventas Exteriores*	50 ➡
LINDA J. JEFFERY Member, Murray School Board of Trustees	*Miembra, Junta de Síndicos del Distrito Escolar de Murray*	51 ➡
THEODORE W. IMPSON Private Patrol Operator	*Operador de Patrulla Particular*	52 ➡
FRED DRENA Businessman	*Hombre de Negocios*	53 ➡
DAVE BURTON Business Consultant-Instructor	*Consultor en Negocios-Instructor*	54 ➡
EDDIE JO MACK Management Analyst	*Analista en Gerencia*	55 ➡
PAUL C. MOFFATT Pharmacist-Corporation President	*Farmacéutico Presidente del Corporación*	56 ➡

END OF BALLOT

3-02E T13, 14

Left: The November 1981 special incorporation ballot asked residents to vote for or against incorporation. The eight council member candidates were also listed on the ballot. *City of Dublin.*

Below: Local activists tracked the city incorporation and city council member election on this chalkboard during the 1981 vote. *Dublin Heritage Park & Museums.*

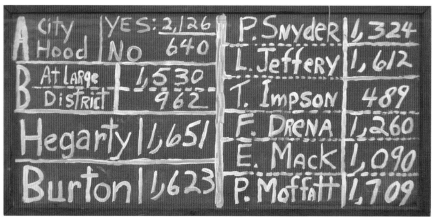

The new city council consisted of a mix of Republicans and Democrats who had lived in Dublin ranging from seven to twenty years. Four of them were among the early home buyers at the time of the Volk McLain development. One of them had moved to Dublin only seven years before. All had been members of early community groups such as Rotary, Lions, the Chamber of Commerce, homeowners' associations and the Dublin Historical Preservation Association. They included self-employed business owners and salaried workers. Some had experience working in county government or boards and the Murray School District.[150]

Amid some pomp and ceremony, Dublin held its first city council meeting on February 2, 1982. The city council began its work and enacted several new ordinances. The council and the residents took an approach to organizing Dublin that reflected prevailing attitudes about government. At the time, it was commonly believed that cities could be more efficiently and economically run if the city manager administered the city, with the city council providing overall direction. Similarly, it was thought that as many city services as feasible should be contracted out to others rather than hiring city staff. In line with that approach and the Alameda County Board of Supervisors' 1979 annexation study, police, fire and public works were contracted out. The Alameda County Sheriff's Office provided police services. The Dublin San Ramon Services District continued to provide water, sewer, fire and parks and recreation services. (The Valley Community Services District changed its name in 1977.) Public works services and the city attorney services were contracted out to private companies. And so, the newly elected council and brand-new city went about its business.

Over the next ten years, Dublin grew and changed. The city council continued to be run by nearly the same people as had been elected in 1982. A major change came in 1992. On June 2, 1992, Dublin's citizens voted in favor of an elected mayor. Resident Guy Houston sponsored the effort as part of a plan to change the way Dublin was developing. His organizing effort also got him name recognition through the door-to-door effort for the measure. One of the arguments in favor of the change was to make the mayor more accountable to the electorate. Arguments against the measure noted that it would cost the taxpayers more money by requiring a separate election and that a directly elected mayor might gain too much power.[151]

From 1982 through 1990, the city council consisted mainly of the original incumbents, with the replacement of Dave Burton by Georgean Vonheeder in 1984. This council represented the activist proponents of incorporation and set about laying the foundations for Dublin's city structure and

Dublin's first city council is sworn in. *From left to right*: Peter Snyder, Linda Jeffery, David Burton, Paul Moffat and Peter Hegarty. *Dublin Heritage Park & Museums.*

operations. The second generation of elected officials started in 1993, when Guy Houston was elected to the council. The new generation included council members who grew up in the Dublin area as children or moved in during the 1970s. The new generation was in place by 1999, when there were no longer any original city council members still serving. By 2000, the city council was working on the plans and processes to guide Dublin's ongoing growth through the early part of the twenty-first century.

PROTECTING DUBLIN: FIRE AND POLICE SERVICES THROUGH THE YEARS

Through the 1800s, Dublin residents depended on one another for help fighting fires. And the mostly wooden buildings easily burned down. Since most farms were quite a distance from one another and well water was the only source of water, brush fires and house fires were nearly impossible to stop once they started. The Dublin crossroads weren't any better off and were possibly worse off since they included restaurants and hotels, with open flames providing light, heat, cooking and recreational smoking. It's probable that some fires were due to patrons drinking in the attached saloons. Dublin hotels regularly burned down in the 1800s and early 1900s.

It wasn't until the 1900s that Alameda County provided a service to deal with fires in the unincorporated areas of the county. Local newspapers often

reported on the fire warden or the fire patrol putting out small fires, especially during the hot, dry summers. The fire patrol was started in 1903 under John McGlinchey and the Stockmen's Protective Association. McGlinchey became the county fire warden in 1907, and the patrol later became part of the Sheriff's Department. In the 1870s and 1880s, Livermore and Pleasanton got by with volunteer fire departments.

The fire patrol and individuals' efforts were eventually supplemented by nearby firefighters. During World War II, Camp Parks and Camp Shoemaker had small fire departments that could respond off base sometimes. They disbanded in 1946. Santa Rita Jail used the old Camp Shoemaker Brig firehouse and offered some support outside the jail from 1947 through 1989. Parks Air Force Base had a fire department from about 1951 through 1959 and helped the nearby community from time to time.

After World War II, some residents tried to organize better local fire protection, and fire protection was one of the founding reasons for the Parks Community Services District. The special district started in April 1953, but there were no actual fire protection capabilities until 1960. Like many things around Dublin, changes came to the Parks Community Services District in the 1960s. It changed its name to Valley Community Services District in 1960, and it began to provide many new services in response to residential and commercial development. It hired its first paid fire chief in October 1961.

In July 1930, the Alameda County Rural Fire Patrol got a new truck. The fire patrol crew posed for a photograph in the new rig. *Livermore Heritage Guild.*

Philip A. Phillips, chief from 1961 through 1987, continued organizing and training the volunteer firefighters. The fact that this wasn't enough became evident when the Dublin Corral bar and restaurant, a mainstay of local entertainment for decades, burned down in 1962.

Firefighting services improved as the first full-time firefighters started in July 1963, and two stations were built by 1968. Harold Ritter became the district's final fire chief in 1987. The Dougherty Regional Fire Authority took over fire protection responsibilities for Dublin and San Ramon from 1988 through 1997. Dublin decided to contract services from the Alameda County Fire Department in July of that year. By 2000, the two original fire stations were still serving Dublin. Alameda County Fire Station No. 16 at 7494 Donohue Drive was the first station built in Dublin by the Valley Community Services District and was also the first station rebuilt. Alameda County Fire Station No. 15 at 5325 Broder Road was built by the Dougherty Regional Fire Authority.

The earliest law enforcement services in the Dublin area came from justices of the peace and constables elected at large in the county and, after 1854, elected in Murray Township. From 1855, there were two constables

The Valley Community Services District built the first Dublin fire station at 7494 Donohue Drive. *Dublin Heritage Park & Museums.*

and two justices of the peace for the sparsely populated township. The Alameda County sheriff showed little interest in the far-away township until Sheriff Harry Morse was elected to his second term in 1865.[152] Morse's biographer mentioned chases, gunfights and arrests throughout Murray Township, with Dublin often being the meeting place for posses searching for criminals.[153] One gunfight took place late one night in November 1867. Morse and Oakland police officer John Conway attempted to arrest murder suspect Narato Ponce on the Hayward/Stockton road near Tassajara Creek. Ponce escaped into the darkness despite several wounds. Morse and his posse eventually confronted and killed Ponce in another gun battle in Pinole Valley in December.[154]

Thereafter, the constables generally took care of minor crimes, with the justice of the peace conducting trials. Cattle and animal theft and minor robberies were the most common offenses. More serious crimes continued to be handled by the Alameda County Sheriff's Office. Local cities expanded their own law enforcement agencies starting in the late 1800s. Livermore started its police department in 1876, and Pleasanton had a town marshal in June 1894.[155]

It wasn't until the 1920s, with the introduction of Prohibition, that federal and state law enforcement actions became more high profile. The local law enforcement presence increased even more when the California Highway Patrol started enforcing traffic laws on state and county highways in August 1929.[156]

Starting in 1947, the Alameda County Sheriff's Office opened a substation at its new Santa Rita Rehabilitation Center. This increased the law enforcement presence in and around Dublin.

Rather than forming its own police and fire departments, the Dublin City Council considered contracting out for those services. The city asked for competitive bids from various agencies, including the Alameda County Sheriff's Office and the East Bay Regional Parks. The Alameda County sheriff was strongly interested in winning the bid, thereby showing that the sheriff's office was a viable candidate to provide police services to other cities. The sheriff won the bid and started providing service in July 1982. The first Dublin police chief was Lieutenant Tom Shores. Despite some early problems, Dublin was very pleased with the service it received. It subsequently renewed the contract, and the Alameda County Sheriff's Office still provides police services to Dublin. Dublin remains one of the few cities in California to contract out its police department.

Dublin's first police vehicles are parked behind the original city offices, sometime during 1982. *Alameda County Sheriff's Office Archive.*

Deputy sheriffs liked working in Dublin. There wasn't much serious crime through most of the end of the twentieth century. Nevertheless, there were a few crimes that shook the small community and periodically reminded the city that there were downsides to growth.

ILENE MISHELOFF AND SERIOUS CRIME IN DUBLIN THROUGH 2001

On the afternoon of January 30, 1989, an eighth-grade girl started walking home from Wells Middle School. Ilene Misheloff never made it home. The disappearance of the young girl from the middle of the town shocked and traumatized the family and almost all of Dublin's nearly twenty-three thousand residents. In such a small town, many people knew members of the well-regarded family, if not Ilene herself. Nothing like this had ever happened in Dublin. Media from around the Bay Area descended on the city. The community rallied around the family, while the San Francisco Bay

Area wondered if this was the third in a series of young girl kidnappings. No one was ever arrested for the disappearance. Even after nearly three decades, about 100 to 150 people still turn out for an annual candlelight vigil, walk and service on the anniversary of the disappearance. Law enforcement agencies still consider the case open.[157]

The Misheloff tragedy was not the only major crime to occur in Dublin, although Dublin is considered one of California's safest cities.[158] In 1986, Harve and Keiko Ringheim were found murdered in their home. No one was ever arrested for that crime. In 2001, Raebelle Elward was beaten to death in the city, and Shawn Reyes was convicted of the crime in 2008. Another huge shock to the city occurred when Alameda County sheriff's deputy John Paul Monego, working as a Dublin police officer, was shot responding to an armed robbery at a local restaurant in 2001. He was the first Dublin police officer to ever die in the line of duty. The three suspects were caught and convicted for Officer Monego's murder and related crimes.

Chapter 7

OUR CHILDREN
GO TO SCHOOL HERE

O rganized education began in the Dublin area in 1854 when Charles Crane started teaching at one of the farms located on Foothill Road. The residents, mainly farm families, took it on their own initiative to hire and pay for the education of their children. At that time, there were probably fewer than fifty people living in and around the Dublin crossroads.

THE ONE ROOM SCHOOLHOUSE ERA, 1854–1952

The next major educational innovation came around 1856, when a one-room schoolhouse was built with land and materials donated by residents. Its first location may have been on Flanagan Road near the large marsh between Dublin and Pleasanton. That area is now the location of Stoneridge Mall. Later, the school was moved because the area was prone to flooding. The new location was about a half mile west and up along the road that went from Dublin to Hayward. Later, it was enlarged into a two-room schoolhouse to take care of the increasing number of students.

On June 5, 1866, residents organized Murray School District. The district was governed by three elected trustees. T.H. Green was the first clerk, T.D. Wells was the first president and J. Dolan was the other trustee. Meanwhile, more people started moving into the area. By 1880, Murray School had

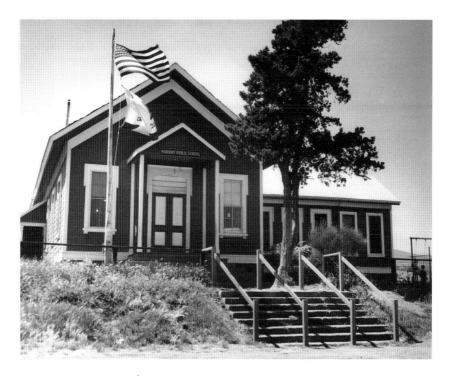

Originally one room, Murray School District's only school was eventually expanded. It eventually moved to the Dublin Heritage Park & Museums in 1975. *Dublin Heritage Park & Museums.*

eighty-seven students. Charles J. Thom was the teacher. Enrollment remained under one hundred students throughout the end of the 1800s.

Throughout the late 1800s and early 1900s, students wanting to attend high school either went to Hayward or to Livermore. In 1922, Amador Valley High School opened in Pleasanton, and Murray graduates had another choice for a high school.[159] By that time, elementary school enrollment had decreased, as local families had opportunities to attend other elementary schools in Pleasanton, Livermore and Hayward.

Transportation to school in the early days was informally arranged. Students either walked to the school, rode horses or got a ride in a horse-drawn cart or wagon. Most students still walked even after gasoline-powered vehicles were introduced into the area after 1900. Students from more well-to-do families got rides in their family's trucks or cars. Murray school continued to have two classes with two teachers: one for first through fourth grade and one for fifth through eighth grade. The number of students ranged between twenty-eight (1927) and sixty-one (1938) for many years.

The Modern Two-Room Schoolhouse Era, 1952–60

After World War II, it appears that there was an increase in the number of students in the area just as the old schoolhouse became increasingly worn out. A new concrete and glass school opened on the southeast side of Dublin Boulevard near the intersection with San Ramon Road (Highway 21 in 1952). The original Murray Schoolhouse had grown too old and too expensive to maintain. The school district sold the original building to a local church soon after 1952.

The First Crazy Growth Era and the End of the Murray School District, 1960–88

By 1963, the Murray School District Board of Trustees had decided to broaden public participation in running the schools. This was in response to the sudden influx of new families and children due to the new 1960 Volk McLain housing development. From its inception, the Murray School District relied on a governing model that included a clerk, a president and one other trustee. The rapid growth would require new schools and staff. The increasing complexity of running several schools seemed to require more public support. In 1963, the first meeting of an expanded board of trustees took place. The new board organization consisted of five trustees: a clerk, a president and three other trustees. A local election brought in three new trustees (Clerk Edward Olheiser, President Frank Stager and Ira Martin) and two trustees with previous experience (George Lydiksen and Robert Nielsen).[160]

Student enrollment increased dramatically starting after 1960. Where there had been 120 students in the previous school year, there were 354 in 1960–61 and 783 in 1961–62. At its first peak eleven years later in the 1972–73 school year, there were 5,892 students in Murray School District.[161]

This increase in student enrollment started a frantic school building program. In 1961, Dublin Elementary opened. In 1963, Brighton Elementary opened. In 1964, Fallon Elementary and Village Elementary opened. Schools opened, closed and rearranged their grade levels with dizzying speed. Temporary portable schools quickly appeared and disappeared as school construction tried to keep up with the nearly

Murray School District had few students for decades. Starting in 1960, Dublin's student population grew dramatically until 1972. Later, it grew tremendously. Data for a few years is unavailable. *Author's research.*

incredible student population growth, which mirrored the general population growth. In the 1960s alone, ten schools opened: Dublin, Brighton, Village, Fallon, Nielsen, Murray (1966), Fredericksen, Lydiksen, Besco (renamed as Donlon) and J.R. Cronin Intermediate. During the same period, three schools closed ("old" Murray, Brighton and Village). To respond to changing student demographics and cases of overcrowding, the district experimented with different combinations of grades within schools, including K-8, K-6, junior highs (seventh and eighth) and intermediate schools (sixth through eighth). The district even experimented with different physical layouts in the schools, including circular classrooms separated by movable partitions.

Recognizing the need for more high schools, plans were made to expand a new Dublin high school into what became the Amador Valley Joint Union High School District. Starting in 1968, students attending Amador High School were split into two daily sessions: mornings for Pleasanton students and afternoons for Dublin students. The plan was to accommodate the rapidly rising high school student population and merge Dublin students into a new high school. Construction on Dublin High began in 1967, and it opened in 1969.

In the 1970s, the Murray School District started to deal with an aging school population, with Wells Intermediate taking on the older students. By the late 1970s, the district started closing schools as the student population declined. Dublin Elementary School closed in 1979.

Coincidentally, the original Murray schoolhouse was obtained in 1975 by the Dublin Historical Preservation Association. It was moved next to old St. Raymond Church and the Dublin cemetery and became the beginning of the Dublin Heritage Center.

In the 1980s, district school enrollment continued to fall, and the district underwent a dramatic change. In 1983, Fallon Elementary closed. The buildings later became the district offices. In 1988, there was a dramatic change in school district structure in both Dublin and Pleasanton. The Murray School District formally closed, and Dublin Unified School District came into being. Lydiksen and Donlon Elementary Schools became part of Pleasanton Unified School District. The Amador Valley Joint Union High School District, which included Amador High School and Dublin High School, disbanded. Dublin High School became part of the new Dublin Unified School District, and Amador High School became part of the Pleasanton Unified School District.

THE SECOND CRAZY GROWTH ERA

From 1993 through 2000, there was a steady annual growth of about 2 percent in the district's student population. But by 2001, Dublin schools had entered a new phase of expansion. Once again it reflected a residential growth spurt, as many new houses, townhouses and apartments were built. The annual percentage growth increased dramatically to a range of 2 to 6 percent each year. However, it wasn't until after 2000 that student enrollment exceeded the levels that it had reached in the 1970s. The history of how Dublin deals with the new growth will have to wait for a few more years.

Chapter 8

WHERE DO WE GO FROM HERE?

D ublin is no longer known in newspapers as the place you go to die or get injured in a grisly automobile accident—although it sometimes still happens. Nowadays, it is more often mentioned as the rapidly growing town where you go to buy million-dollar homes yet still endure hours-long commutes to Silicon Valley or San Francisco. Gone are the wide-open spaces with an occasional cow munching hay along the side of the road. Replacing that is one of the youngest cities in California trying to come to terms with growth, housing, schools and traffic. Dublin evolved over time. Its longest legacy started with the Native Americans, who lived here for hundreds of generations. After that came the contentious mission, Mexican land grant, gold rush, agriculture, road building, naval and military base, suburban subdivisions and incorporation periods, each with its own trials, tribulations and effects. Throughout its history, and especially since 2000, Dublin and its residents have labored to build their version of just the right community.

NOTES

Chapter 1

1. Hilgard, "Report on Cotton Production," part II, 769. Author's estimate.
2. Madley, *American Genocide*, 40.
3. Lane, "Bay Miwok Language and Land," 11.
4. Milliken, *Time of Little Choice*, 1.
5. Ibid., *Native Americans*, 15.
6. Ibid., *Time of Little Choice*, 6–7.
7. Ibid., 228–29, Appendix 1, named groups, "Encyclopedia of Tribal Groups."
8. Map of tribe locations, Muwekma Ohlone Tribe of the San Francisco Bay Area, http://www.muwekma.org.
9. Milliken, *Native Americans*, 23.
10. Ibid., 23.
11. Lane, "They Came First," 2.
12. Milliken, *Native Americans*, 4.
13. Ibid., 45.
14. Ibid., 64.
15. Ibid., 4.
16. Ibid., 73–77.
17. Hass, "War in California, 1846–1848," 334.
18. *Oakland Tribune*, "A Relic," June 28, 1875.
19. Muwekma Ohlone Tribe of the San Francisco Bay Area website.

Chapter 2

20. Stuart and Stuart, *Corridor Country*, 53.

21. Wikipedia, "Jose Maria Amador," https://en.wikipedia.org/wiki/Jos%C3%A9_Mar%C3%ADa_Amador.

22. Milliken, *Native Americans*, 3.

23. Bennett, *Dublin Reflections*, 46.

24. Shoup, *Rulers & Rebels*, 55.

25. Bidwell, "Life in California Before the Gold Discovery," 70, Google Books.

26. Bancroft, *Works of Hubert Howe Bancroft*, 585, footnote.

27. Notes from Museum of the San Ramon Valley files, referencing the George C. Collier collection of works on California history, circa 1850–90, Bancroft Library.

28. Bennett, *Dublin Reflections*, 2, 49–66.

29. Foxworthy, *Foxworthy-Fallon Saga*, 75.

30. Mokyr, "Great Famine, Irish History."

31. Rosen, Donner Party, "Log Entries for April, 1847."

32. Originally published in the Harness Racing Museum's 1994 book, *The Immortals*. Harness Racing Museum & Hall of Fame webpage, "Directum."

33. The information in this paragraph comes from McCormick, *Kolbs of Dublin*.

34. 1880 U.S. Federal Census, "California, Alameda County, Murray Township, Enumeration District 26," June 5, 1880, 10–11.

35. Lane, *Dougherty Valley*, 5.

36. Notes from Museum of the San Ramon Valley files, referencing the George C. Collier collection of works on California history, circa 1850–90, Bancroft Library.

37. U.S. Census, 1860, California, Alameda County, Murray Township, August 11, 1860, 227–28.

38. Wood, *History of Alameda County*, 654.

39. Alameda County Board of Supervisors Minutes, Supervisors' Records, vol. 1, 1853–62.

40. *Oakland Tribune*, "Dougherty's Estate," October 9, 1879.

41. Wood, *History of Alameda County*, 468.

42. Hoover, Rensch and Rensch, *Historic Spots in California*, 13.

43. *Livermore Journal*, "Early Day Data of Valley Given by Honor Pupil," June 26, 1930, 3. Norine Bianchi gave the commencement talk at the Amador Valley Union High School that contained the information in the article.

44. Hoover, Rensch and Rensch, *Historic Spots in California*, 13.

45. *Daily Alta California*, "A Trip to Amador Valley," September 21, 1865, 1.

46. *Pacific Rural Press*, "Notes of Travel in Alameda and Contra Costa Counties—Continued," January 13, 1872, 18.

47. *Livermore Herald*, advertisement, March 28, 1877.

48. Maps of the Past, *Alameda County California (CA) Landowner Map 1878*.

49. *Livermore Herald*, "Board of Supervisors," April 8, 1884, 3.

50. Hoover, Rensch and Rensch, *Historic Spots in California*, 13.

51. Wood, *History of Alameda County*, 459.

52. Ibid.

53. Ibid., 462.

54. Ibid., 464.

55. Ibid. In the biographical sketches section of his book, Wood stated that Joseph Black was the first to farm in Dublin in 1859.

56. Ibid., 465.

57. Ibid., 466.

58. Halley, *Centennial Year Book*, 496.

59. Wood, *History of Alameda County*, 464.

60. Ibid., 467.

61. Ibid.

62. Halley, *Centennial Year Book*, 493.

63. Ibid., 505.

64. *Livermore Herald*, "Local Brieflets," April 11, 1877, 3.

65. Wood, *History of Alameda County*, 458.

66. Colquhoun, *Illustrated Album of Alameda County*, 56–57.

67. Ibid., 10–11.

68. Ibid., 6.

69. *Pacific Rural Press*, "More Grain than Supposed," September 21, 1907.

70. Ibid., "Agriculture," September 19, 1908.

71. *Livermore Journal*, "Beet Harvest to Start," October 9, 1926. Spreckles was in Monterey County.

72. Alameda County Board of Supervisors, *Alameda County Agriculture and Road Map*, 1937.

73. Callaghan, *Appraisal Lands and Improvements*, October 29, 1942, 98.

74. Ibid., multiple pages.

75. Dotson, *San Ramon Branch Line*.

76. *Livermore Journal*, "White Angel Starts on Trip North," March 31, 1933.

77. Wm. T. Davis, "White Angel Establishes Camp in Valley," *Livermore Journal*, March 14, 1933.

78. *Pleasanton Times*, "White Angel Plans to Have Harvest Festival Near Dublin," September 29, 1933.

79. *Tri-Valley Herald*, Dublin Founders' Day Supplement, September 21, 1985.

80. The information in this section comes from Volk McLain scrapbooks held by the City of San Ramon at Forest Home Farms Historic Park. One scrapbook detailed many activities from before 1960 through the period just after 1966. For some unidentified reason, there was no mention of activities in 1965 in the book.

81. *The Times*, "There's More to the VCSD than Meets the Political Eye," March 20, 1968, 1.

82. *Alameda County Library, a Century of Service: A Visual History of the Dublin Library*. Pamphlet published by the Alameda County Public Library, Dublin branch. The library reopened, after being closed since 1948, on April 9, 1966, in a portable room near Dublin Elementary School. http://guides.aclibrary.org/content.php?pid=121671&sid=4887738.

83. Bezis, "I-580/I-680 Junction," 6.

84. Wikipedia, "Dublin High School (Dublin, California)," http://en.wikipedia.org/wiki/Dublin_High_School_(Dublin,_California).

85. *Dublin San Ramon Services District*, 5.

86. John Oliver and Jerry Breeden, "Last Corpsman Leaves Parks," *Herald News*, Dublin Supplement, June 18, 1969.

87. *Alameda County Library, a Century of Service*. The library opened on March 1, 1970.

88. Wikipedia, "Dublin High School (Dublin, California)."

89. *Dublin San Ramon Services District*, 5.

90. *Alameda County Library, a Century of Service*. The library opened on March 21, 1979.

91. California Association of Local Agency Formation Commissions, "California Cities by Incorporation Date," retrieved March 27, 2013, copied from Wikipedia October 7, 2015. Dublin was incorporated on February 1, 1982.

Chapter 3

92. *Livermore Herald*, "Board of Supervisors," April 8, 1880.

93. *Daily Alta California*, "A Trip to Amador Valley," September 21, 1865.

94. *Tri-City Voice*, "History: Stagecoach!" July 13, 2010, online edition; Merritt, *History of Alameda County, California*, vol. 1, 441.

95. *Tri-City Voice*, "History: Stagecoach!"

96. *Pacific Coast Directory*, "Dublin," 1867, 134.

97. *Livermore Herald*, "Valley and Canyon," April 18, 1884.

98. *Marysville Daily Appeal*, "The Bulmer Hill Stage Accident," June 19, 1869. News of the accident was also reported in the *Marin Journal* on June 26, 1869.

99. *Pacific Rural Press*, December 28, 1877.

100. *Livermore Herald*, "Dublin Items, Dublin, May 30th," June 1, 1882.

101. *San Francisco Call*, "Automobile in the Park," February 23, 1900.

102. *Daily Review*, "Automobile Causes Accident," November 10, 1899.

103. *Principal Facts Concerning the First Transcontinental Army*, "Vehicles."

104. Eisenhower, *At Ease*, 167.

105. Corbett, "Historical and Cultural Resource Survey," 3.

106. Lincoln Highway Association website, https://www.lincolnhighway assoc.org.

107. *Tri-City Voice*, "Prohibition in Hayward," June 12, 2007, http://www.tricityvoice.com/articlefiledisplay.php?issue=2007-06-12&file=Prohibition+-+Hayward.txt.

108. *Oakland Tribune*, "House, Alleged to Have Been Built for Distillery, Is Scene of Capture," September 22, 1922.

109. *San Bernardino County Sun*, "Major Liquor Haul," January 19, 1922.

110. *San Francisco Chronicle*, "Guns Ordered for War upon Liquor Bandits," January 29, 1922.

111. *Hayward Review*, John Sandoval, "Purely Personal: Peter Hoare," May 6, 1946.

112. *Hayward Semi-Weekly Review*, "Dublin Highway Paving Started and Road Closed," June 14, 1927.

113. *Livermore Journal*, "Four Pleasanton Youths Arrested in Milk War," November 21, 1924.

114. *Hayward Daily Review*, "Week-End Auto Crashes Many, Five Are Hurt," February 24, 1930.

115. *Livermore Journal*, "Engineers Survey Dublin Highway," November 26, 1931.

116. Ibid., "Dublin Canyon Work to Start," January 26, 1933.

117. Skeggs, "Dublin Canyon Multi-Lane Arterial," 4–5, 19.

118. Gillis, *California*, 587.

119. Sinclair, "Freeways in District IV," 13.

120. April 26, 2016 average daily traffic volume, City of Dublin, GIS Portal, San Ramon Road between Amador Valley Boulevard and Dublin Boulevard.

121. Wood, *History of Alameda County*, 468, 475.

122. *Livermore Herald*, "Dublin," June 1, 1882.

123. Harry Rowell Family, "Elizabeth Rowell Leuschner"; Harry Rowell Family, "C.O. "Dogtown Slim Leuscher.""

124. Bay Area Rapid Transit, "A History of BART.""

Chapter 4

125. Callaghan, *Appraisal Lands and Improvements*, 3–4.

126. Seabee Museum and Memorial Park, Rhode Island, "Seabee History World War II."

127. *Rawlins (WY) Daily Times*, "Harry Robert "Bob" Herring," obituary.

128. Story told to author by William Meine, 2015.

129. Wikipedia, "Naval Station Great Lakes." https://en.wikipedia.org/wiki/Naval_Station_Great_Lakes#World_War_II.

130. Jones, *Football! Navy! War!*, 49–50.

131. *New York Times*, "Buddy Young, Ex-Football Star," September 6, 1983.

132. Handwritten notes, "Dublin Housing Notes," clipping files, Alameda County Library, Dublin branch, A.

133. Betty King Buginas, "Komandorski Families Are Ready for New Housing," *Valley Times*, July 15, 1982; "Dublin Housing Notes," Alameda County Library.

134. Handwritten notes and newspaper clippings, "Dublin Housing Notes," Alameda County Library, A–G and clippings.

135. Stevens Historical Research Associates, "12/9/15—The History of the War Assets Administration."

136. Davis, *Stages of Emergency*, 135.

137. W.E. Strope et al., *Family Occupancy Test*, 1 (abstract).

138. Ibid., 62.

139. Menkes, *Dosimetry for Large Animal Experiments*, 1.

140. Review of local newspaper titles found in *Bunshah Index* for 1994, when a series of articles discussed radiation testing at Camp Parks.

141. Job Corps, "About Job Corps."

142. *San Luis Obispo Telegram-Tribune*, "How It Worked at Pleasanton; No Mass Liberties for Job Corps," circa September 1965.

Chapter 5

143. *United States Naval Administration in World War II*, "History of U.S. Naval Disciplinary Barracks, Shoemaker, California," 1, Appendix, Commandant, Twelfth Naval District, circa 1946.

144. *San Francisco Sunday Examiner & Chronicle*, "An Inhuman Place Called 'Rita'," November 27, 1983.

145. Alameda County Sheriff's Office, "Santa Rita Jail Facts."

146. Information provided to author via e-mail by Sally Swarts, public information officer, Federal Correctional Institution, Dublin, August 4, 2017.

Chapter 6

147. Alameda LAFCo, "About Us, History of LAFCO"; Alameda LAFCo, "About Us, Legislative Act."

148. Kresge-Cingal, *Dublin California*, 19.

149. Zion, *Service and Fiscal Feasibility Study*, undated copy found in Dublin Library clipping files under "Incorporation," 1. Kresge-Cingal stated that the report went to the Alameda County Board of Supervisors on July 22, 1980.

150. Kresge-Cingal, "Dublin, California," 31–32.

151. Ibid., 34–35.

152. MacLennan, *Pleasanton, California*, 35.

153. Boesscnecker, *Lawman*, 26, 30, 54, 77, 84.

154. Ibid., 89–93.

155. MacLennan, *Pleasanton, California*, 72.

156. California Highway Patrol, "History of the California Highway Patrol."

157. Carol Graham, "Search Goes on for Answers to Missing Girl," *Independent*, January 26, 2016, web version posted January 28, 2016, http://www.independentnews.com/news/search-goes-on-for-answers-to-missing-girl/article_b8c45e1a-c571-11e5-9e62-4f6b9f62fbdf.html.

158. Gulliford, "2016 Safest Places in California," Value Penguin. Dublin was ranked eighty-second among the one hundred safest cities in 2016.

Chapter 7

159. Long, *Echoes of School Bells*, 30.
160. "Murray School District Trustees," typewritten document, circa June 30, 1988, Murray School District, provided by Edra O. Coleman, the last president of the Murray School District Board of Trustees. This document was prepared by the Murray School District for a project celebrating one hundred years of work and documenting the district's conclusion.
161. Student enrollment information comes from many sources, some less accurate than others. Information for some periods has not been found yet (as of 2015). Early enrollment information (1880–91) tends to come from anecdotes and local newspaper articles. Enrollment information from 1909 to 1949 was found in newspaper articles and counting students in class photos. Information from 1953 to 1976 came from school district records. Information from 1993 to 2015 came from California State Office of Education, Alameda County Schools office and Dublin Unified School District publications.

BIBLIOGRAPHY

Alameda County Board of Supervisors. *Alameda County Agriculture and Road Map*. Oakland, CA: Development Commission, 1937.

Alameda County Sheriff's Office. "Santa Rita Jail Facts." https://www.alamedacountysheriff.org/dc_srj.php.

Alameda LAFCo. "History of LAFCO." https://www.acgov.org/lafco/history.htm.

———. "Legislative Act." https://www.acgov.org/lafco/act.htm.

Bancroft, Hubert H. *The Works of Hubert Howe Bancroft*. Vol. 19. Santa Barbara, CA: Wallace Hebberd, 585.

Bay Area Rapid Transit. "A History of BART." http://www.bart.gov/about/history.

Bennett, Virginia Smith. *Dublin Reflections and Bits of Valley History*. Union City, CA: Mill Creek Press, 1978.

Bezis, Jason. "I-580/I-680 Junction: Tri-Valley Crossroads Is [*sic*] 50 Years Old." *Newsletter*, March 2016, 6. Livermore Heritage Guild.

Bidwell, John. "Life in California Before the Gold Discovery." *Century Magazine* 41, no. 2 (December 1890): 70. Google Books, https://books.google.com/books?id=bVplPnbJsygC&pg=PA69&lpg=PA69&dq=john+bidwell+life+in+california+before+the+gold+discovery&source=bl&ots=TEyMhWpiLw&sig=QjXPHZ1Zf2gPdtyVmtII4FwVYgc&hl=en&sa=X&ved=0ahUKEwiSyMH1rffTAhUBH2MKHVMwCdA4ChDoAQg1MAc#v=onepage&q=amador&f=false.

Boesscnecker, John. *Lawman: The Life and Times of Harry Morse, 1836–1912.* Norman: University of Oklahoma Press, 1998.

California Highway Patrol. "History of the California Highway Patrol." https://www.chp.ca.gov/home/about-us/the-history-of-the-california-highway-patrol.

Callaghan, M.G. *Appraisal Lands and Improvements for Recuperation and Replacement Center in Alameda and Contra Costa Counties California for the United States Navy.* N.p.: self-published, October 29, 1942.

Colquhoun, Jos. Alex., comp. *Illustrated Album of Alameda County, California.* N.p.: Pacific Press Publishing Company, 1893.

Cooper, Paul L. *Warriors of the Gridiron: From War to Peace.* Pittsburgh, PA: Rosedog Books, 2006.

Corbett, Michael R. "Historical and Cultural Resource Survey: East Alameda County." Prepared for Alameda County Community Development Agency, Hayward, California, 2005.

Davis, Tracy C. *Stages of Emergency: Cold War Nuclear Civil Defense.* Durham, NC: Duke University Press, 2007.

Denvnich, Grace E. "Dougherty." *Western Express Research Journal of Early Western Mails* (July 1990).

———. "Postal History of Murray Township, Alameda County, California." *Western Express Research Journal of Early Western Mails* (July 1987).

Dotson, Irma M. *San Ramon Branch of the Southern Pacific.* Danville, CA: Museum of the San Ramon Valley, 1991.

Dublin San Ramon Services District: The First Fifty Years, 1953–2003. Dublin, CA: Dublin San Ramon Services District, 2013.

Eisenhower, Dwight D. *At Ease: Stories I Tell to Friends.* Garden City, NY: Doubleday & Company, 1967.

Farris, Glen J. "Review of *A Time of Little Choice: The Disintegration of Tribal Culture in the San Francisco Bay Area, 1769–1810.*" N.p.: Ballena Press, 1995.

Foxworthy, Donald F. *The Foxworthy-Fallon Saga*, 1989. N.p.: Livermore-Amador Genealogical Society, 2004.

Gillis, Mabel R. *California: A Guide to the Golden State.* New York: Hastings House, 1939.

Gulliford, Susan. "2016 Safest Places in California." Value Penguin. https://www.valuepenguin.com/2016/safest-places-california.

Halley, William. *The Centennial Year Book of Alameda County, California.* Oakland, CA: William Halley, 1876.

The Harry Rowell Family: A Rodeo Legacy. "C.O. 'Dogtown Slim' Leuscher." http://theharryrowellfamily.org/harryrowellfamilyhistory.htm.

————. "Elizabeth Rowell Leuschner." http://theharryrowellfamily.org/harryrowellfamilyhistory.htm.

Hass, Lisbeth. "War in California, 1846–1848." *California History* 76 (Summer/Fall 1997): 334.

Hilgard, Eugene W. "Report on Cotton Production in the United States Also Embracing Agricultural and Physico-Geographical Descriptions of the Several Cotton States and of California." Part 2. Washington, D.C.: Government Printing Office, 1884.

Hoover, Mildred, Hero Eugene Rensch and Ethel Grace Rensch. *Historic Spots in California.* Edited by William N. Abeloe. Stanford, CA: Stanford University Press, 1966.

Ignoffo, Mary Jo. *Gold Rush Politics: California's First Legislature.* Sacramento: California State Senate and the California History Center and Foundation, 1999.

Job Corps. "About Job Corps." https://www.jobcorps.gov/page/citizens.

Jones, Wilbur D., Jr. *Football! Navy! War!: How Military Lend-Lease Players Saved the College Game.* Jefferson, NC: McFarland & Company, 2009.

Kresge-Cingal, Delphine. "Dublin, California: From a Town to a City." Mémoire de maîtrise (Master 1), Paris IV–Sorbonne, 1991–92.

Lane, Beverly. "The Bay Miwok Language and Land." *The Bay Miwok: First People of Contra Costa County* (2003): 11.

————. *The Dougherty Valley: California History in Our Backyard.* Rev. ed. Martinez, CA: Contra Costa County Historical Society, 2016.

————. *San Ramon Chronicles: Stories of Bygone Days.* Charleston, SC: The History Press, 2015.

————. "They Came First: The Indians of the San Ramon Valley." Museum of the San Ramon Valley, n.d.

Lane, Beverly, and Laura Grinstead. *Vintage Danville: 150 Years of Memories.* Virginia Beach, VA: Donning Company Publishers, 2008.

Lane, Beverly, and Ralph Lane. *San Ramon Valley: Alamo, Danville, and San Ramon.* Charleston, SC: Arcadia Publishing, 2005.

Long, Jerri Pantages. *Echoes of School Bells: A History of Amador-Pleasanton Public Schools, 1864–1988.* Livermore, CA: Quali-Type Inc., 1989.

Lynch, Mike, and the Dublin Heritage Center. *Dublin.* Charleston, SC: Arcadia Publishing, 2007.

MacLennan, Ken. *Pleasanton, California: A Brief History.* Charleston, SC: The History Press, 2014.

Madley, Benjamin. *An American Genocide.* New Haven, CT: Yale University Press, 2016.

Maps of the Past. *Alameda County California (CA) Landowner Map 1878.* http://www.mapsofthepast.com/alameda-county-california-landowner-map-1878.html.

Marques, Heather. *Alameda County Fire Department.* Charleston, SC: Arcadia Publishing, 2016.

McCormick, Claudia. *The Kolbs of Dublin.* Dublin, CA: City of Dublin, 2011.

Menkes, Cirel K. *Dosimetry for Large Animal Experiments Using Multiple Co60 Sources and 1 MVP X-Rays.* San Francisco, CA: U.S. Naval Radiological Defense Laboratory, June 8, 1965.

Merritt, Frank Clinton. *History of Alameda County, California.* Vol. 1. Chicago: S.J. Clarke Publishing Company, 1928.

Milliken, Randall. *Native Americans at Mission San Jose.* Banning, CA: Malki-Ballena Press, 2008.

———. *A Time of Little Choice: The Disintegration of Tribal Culture in the San Francisco Bay Area, 1769–1810.* Menlo Park, CA: Ballena Press, 1995.

Minniear, Steven, and Georgean Vonheeder-Leopold. *Dublin and the Tri-Valley: The World War II Years.* Charleston, SC: Arcadia Publishing, 2013.

Mokyr, Joel. "Great Famine, Irish History." *Encyclopedia Britannica.* https://www.britannica.com/event/Great-Famine-Irish-history.

Moro-Torres, Gregorio. *Californio Voices: The Oral Memories of José Maria Amador and Lorenzo Asisara.* Denton: University of North Texas Press, 2005.

Okihiro, Gary Y. *American History Unbound: Asians and Pacific Islanders.* Berkeley: University of California Press, 2015.

Ortiz, Beverly. *Ohlone Curriculum with Bay Miwok Content and Introduction to Delta Yokuts.* 2nd ed. Oakland, CA: East Bay Regional Park District, 2015.

Principal Facts Concerning the First Transcontinental Army Motor Transport Expedition, Washington to San Francisco, July 7 to September 6, 1919. "Vehicles." Information from report by Captain William C. Greany, U.S. Army.

Rosen, Daniel M. The Donner Party. "Log Entries for April, 1847." http://www.donnerpartydiary.com/apr47.htm.

Salley, Harold E. *History of California Post Offices, 1849–1976.* Spring Valley, CA: Heartland Printing and Publishing Company, 1977.

Seabee Museum and Memorial Park, Rhode Island. "Seabee History World War II." http://www.seabeesmuseum.com/seabee-history.

Shoup, Laurence H. *Rulers & Rebels: A People's History of Early California, 1769–1901.* New York: iUniverse Inc., 2010.

Sinclair, J.P. "Freeways in District IV." *California Highways* (March–April 1960).

Skeggs, Jno. H. "Dublin Canyon Multi-Lane Arterial an Outstanding Highway Achievement." *California Highways and Public Works.* Sacramento: California State Department of Highways, 1934.

Starr, Kevin. *Embattled Dreams: California in War and Peace, 1940–1950.* New York: Oxford University Press, 2002.

Steele, Carole MacRobert. *Phoebe's House: A Hearst Legacy.* Eugene, OR: Luminare Press, 2016.

Stevens Historical Research Associates. "12/9/15—The History of the War Assets Administration." http://www.shraboise.com/2015/12/12915-the-history-of-the-war-assets-administration.

Strope, W.E., et al. *Family Occupancy Test: 4–6 November 1960.* San Francisco, CA: U.S. Naval Radiological Defense Laboratory, August 22, 1962.

Stuart, Reginald R., and Grace D. Stuart. *Corridor Country: An Interpretive History of the Amador–Livermore Valley.* Vol. 1, *The Spanish-Mexican Period.* Livermore, CA: Amador-Livermore Valley Historical Society, 1966.

U.S. Federal Census. "California, Alameda County, Murray Township, [Enumeration District] 11." August 1860, 227–28. http://www.usgwcensus.org/cenfiles/ca/alameda/1860/murray/murray.txt.

———. "California, Alameda County, Murray Township, Enumeration District 26." June 5, 1880.

Wainwright, Mary-Jo, and the Museum on Main. *Pleasanton.* Charleston, SC: Arcadia Publishing, 2007.

Wood, M.W. *History of Alameda County.* Oakland, CA: Pacific Press, 1883.

Zion, William R. *Service and Fiscal Feasibility Study: Incorporation of Dublin, Annexation of Dublin to Pleasanton.* Lafayette, CA: William R. Zion, 1980.

INDEX

ABOUT THE AUTHOR

Steve Minniear moved to Dublin in 1987, like so many others looking for an affordable house, a place to raise his family, good schools and a reasonable commute. He found what he was looking for. Steve has a master's degree from Georgetown University in government. He received his bachelor's degree from the University of California–Berkeley in political science. He served eight years on the City of Dublin Heritage and Cultural Arts Commission. He is the president of the Dublin Historical Preservation Association. Mr. Minniear is a member of the California Association of Museums, California Conference of Historical Societies and the Society for Military History. He co-wrote *Dublin and the Tri-Valley: The World War II Years*. He wrote content for several webpages on the history of Camp Parks, Camp Shoemaker, Shoemaker Naval Hospital, Parks Air Force Base and the Murray School District/Dublin Unified School District. Mr. Minniear designed local history exhibits for the Dublin Heritage Park & Museums and the Dublin branch of the Alameda County Library.

Visit us at
www.historypress.com

31901063542437